LEGEN

MOLINE
ILLINOIS

Moline Begins
A lithographic plate illustrates an upstream view of the Moline riverfront in 1832, with David Sears's brush dam between the Moline shoreline (right) and Rock Island, today known as Arsenal Island (left). (Courtesy of the Rock Island County Historical Society.)

Page 1: Fifth Avenue
This early-1900s photograph looks east along a busy Fifth Avenue from Fourteenth Street. The Carlson Brothers office-products store is on the left, and the People's Power Company showroom is on the right. (Courtesy of the Rock Island County Historical Society.)

LEGENDARY LOCALS
OF
MOLINE
ILLINOIS

DAVID T. COOPMAN

Copyright © 2016 by David T. Coopman
ISBN 978-1-4671-0235-3

Legendary Locals is an imprint of Arcadia Publishing
Charleston, South Carolina

Printed in the United States of America

Library of Congress Control Number: 2015947969

For all general information, please contact Arcadia Publishing:
Telephone 843-853-2070
Fax 843-853-0044
E-mail sales@arcadiapublishing.com
For customer service and orders:
Toll-Free 1-888-313-2665

Visit us on the Internet at www.arcadiapublishing.com

Dedication
For those who are unaware of some of the institutions and unique individuals who have made Moline what it is today.

On the Front Cover: Clockwise from top left:
Thomas Railsback (right), former US representative (Courtesy of Earl Wendt; see page 70), Delores Bultinck, honorary consul of Belgium (Courtesy of Center for Belgian Culture; see page 72), John Baker, Congressional Medal of Honor recipient (Courtesy of Ray Hamilton; see page 53), Stephanie Sundine, opera singer (Courtesy of Stephanie Sundine; see page 89), Dr. James Collinson, professor and archeologist (Courtesy of Dr. James Collinson; see page 86), Brad Hopkins, professional football player (Courtesy of the Tennessee Titans; see page 117), Louis Bellson, percussionist and composer (Courtesy of the Moline Dispatch Publishing Company; see pages 80, 81).

On the Back Cover: From left to right:
G. LaVerne Flambo, businessman and impresario (Courtesy of John Flambo; see page 47), Jim King (center), news anchor and MDA Telethon host (Courtesy of Gloria Ketz; see page 109).

CONTENTS

Acknowledgments 6

Introduction 7

CHAPTER ONE Patriarchs and Pioneers 9

CHAPTER TWO Community Leaders, Interesting Deeds 39

CHAPTER THREE Arts, Culture, and Academics 79

CHAPTER FOUR Media and Sports 101

Index 126

ACKNOWLEDGMENTS

This volume provides sketches and images of local legends that made up Moline's rich history and those whose lives were enriched by the quality of life that was provided them by growing up or residing in Moline.

In addition to the individuals and sources noted in the various page captions, I am indebted to the following people and institutions for their contributions of photographs, information, and encouragement: the staff of the Rock Island County Historical Society Library (RICHS), including Orin Rockhold, Kathleen Seusy, Shirley Ricketts, and Merredith Peterson; Laura Yeater and Todd Mizener of the Moline Dispatch Publishing Company (MDPC); the Center for Belgian Culture; Bruce Carter and Cathie Rochau of the Quad City International Airport; Chris VanLancker of Model Printers; Gretchen Small at the William Butterworth Trust; Samantha Crisp and the Augustana College Library Special Collections; WQAD-TV; Dr. Curtis Roseman, James Kron, Gloria Ketz, Judith Carls, Steve Slininger, Ray Hamilton, Lawrence Eyre, Willie McAdams, Jerry Wallaert, Tom Lundahl, Kathryn Reimers Manning, and Jeff and Jon Tunberg; and Dr. Gus Harb. A special thank-you goes to Erin Vosgien, editor at Arcadia Publishing, for her assistance, encouragement, and understanding.

INTRODUCTION

Moline began as a mill town. Thanks to David Benton Sears and his dam across a section of the Mississippi River, waterpower allowed gristmills and lumber mills to flourish. John Spencer, a business partner of Sears, once said, "Water power made Moline, and D.B. Sears was the father of the water power."

Sears arrived in Rock Island Mills (yet to be called Moline) in 1836. He purchased a strip of land along the river across from Rock Island. By 1838, Sears had acquired nearly 1,200 acres of land and was operating a flour mill and sawmill. With partners Spencer White and John Spencer, Sears built a brush dam across the slough between Rock Island and his shoreline land in 1838. With the completion of that dam, a machine shop and forge, a wooden ware factory, and additional mills were established.

In 1843, the town was platted by Sears, Spenser, White, Joel and Huntington Wells, Charles Atkinson, and Nathan Bass, but it was still unnamed. On one plat, the surveyor had written "Hesperia," and on another, "Moline." The first name means "star of the west," and the second is a variation of the French word for "mill town." Charles Atkinson stated, "Moline, let it be called."

With abundant waterpower and better transportation for materials and finished product, John Deere moved his plow manufacturer here from Grand Detour, Illinois, in 1848. An increasing number of agriculture-implement manufacturers sprang up, as well. In time, Moline would become part of the area's prominence as "the farm-implement capital of the world."

Through the efforts of Charles Atkinson, the Chicago & Rock Island Railroad changed its original route west and came through the industrial area of Moline on its way to crossing the Mississippi River.

As the number of manufacturing firms steadily grew, so did job opportunities. Immigrants from Sweden, Belgium, and Germany began to file into Moline in the mid-to-late 1800s to fill the need for factory labor. They were joined a little later by those from Greece, Ireland, and Mexico. The newly arriving immigrants, however, were not only laborers; many were skilled craftsmen who began creating their own businesses. Many of those same businesses still exist today and are locally and nationally known.

By 1890, the city was flourishing. It had a fire department, library, water plant, garbage-collection system, electric lights in factories and stores, and electric streetcars. Clubs were organized, and these had influence on the social, literary, moral, philanthropic, and educational climate of Moline. Some of those influential roots are still seen today in the parks and mansions donated to the city by prosperous leading citizens, to be used for the benefit of all city residents.

The early 1900s brought automobile and airplane manufacturing to Moline. Willard Velie and his son began building the Monocoupe airplane, in addition to their cars, trucks, and engines. Several automobile brands were created and built in Moline, but all were gone by the late 1920s.

By the last half of the 20th century, the farm crisis, competition, mergers, and downsizing took their toll on the agriculture-implement businesses. Moline had to reinvent itself. The city began to grow in the retail and business service sectors. Through public-private initiatives, the downtown was revitalized, as former industrial properties along the riverfront were converted into retail and housing developments, and a civic arena, parkways, and walking and biking paths were created.

Tourism has now become a major draw, via concerts and events at the iWireless Center and visitors to the John Deere Pavilion, a learning center for Midwest agriculture and a showcase for Deere products old and new.

Through all of Moline's history, one thing stands out: its people. There were the progressive thinkers who created and furthered industries; ethnic leaders who developed neighborhoods and social programs for their immigrant colleagues; organizers of service groups and programs; and citizens who answered the call whenever volunteers were needed, doing work purely for the betterment of all of Moline.

The city has produced educators, scientists, inventors, nationally known politicians and public servants, stars of television, cinema, opera and music, and famous athletes. This volume will tell not

only the stories of some of Moline's well-known sons and daughters, past and present, but some of the not-so-well-known people and their stories. Several noteworthy organizations and iconic places are also included. Many residents have brought distinction to themselves and Moline. All have contributed to making Moline what it is today.

Winner's Celebration
Belgian immigrants to Moline brought many of their traditions with them, including pigeon racing. Friends, competitors, and even local band members gathered to salute the winning bird's owner at the Moline Pigeon Club. (Courtesy of the Center for Belgian Culture.)

CHAPTER ONE

Patriarchs and Pioneers

Mound builders and other early natives were perhaps the first real pioneers to the Moline area. In the late 1600s, the Sac and Fox Indians had entered the region, but battles, treaties, and statehood would eventually open the land for settlement. By 1829, the first inhabitants arrived, and the settlement of what would evolve as Moline began.

Most of the early settlers had come west to find better lives than what they had been experiencing back east, including entrepreneurs who had great plans of starting over and building a completely new way of life. David Sears was one of the first. Intending to farm, he purchased a large tract of land along the riverfront, but soon saw the potential of the Mississippi River supplying power for industry. His dam on the river drew others, and Moline became a town. Charles Atkinson named the town, helped bring plowmaker John Deere to Moline, and convinced a railroad to build a route through the industrial district.

As the town and its services grew, more industry was established. Herman Barnard switched from making furniture to the manufacture of milling equipment. Alexander Montgomery started a freight- and passenger-elevator business. George Stephens would become the biggest competitor to John Deere's company. Willard Velie transitioned from manufacturing wagons and carriages into building automobiles, which spurred the Borg & Beck Company into inventing the modern automotive clutch. Frederick Lundahl produced automobile parts, but transformed his firm into a legendary toy company.

With large-scale industry firmly established and growing in Moline, immigrants from Europe flocked to the area for work. Dr. Jacob Stewart saw the need for affordable housing for those workers and created a suburban development called Stewartville. Edward Coryn, a Belgian immigrant himself, helped other Belgians assimilate into their new homeland.

Women were not left out of Moline's transformation. Mary Stewart led a fight for temperance. Mattie Poole, possibly the city's first successful businesswoman, opened a prominent art store and china decorating business. Eldorado Jones had several successful inventions, including one that was never given a chance. Phoebe Omlie made her mark in aviation.

These individuals and others in this chapter had the pioneering spirit that either created Moline or founded something unique within the city that made it distinctive. They are truly patriarchs and pioneers of Moline.

David Benton Sears

Sears, considered the first person to use the water of the Mississippi River to generate power, was born in New York State and eventually settled in southern Illinois. In 1836, he came to what would later be called Moline. Sears purchased a strip of land along the river, across from what was then called Rock Island. With others, he platted the land that became Moline. Raised with farming, Sears soon recognized the need for factories to supply the implements for early settlers to the area. Along with partners John Spencer and Spencer White, Sears built a brush dam from the tip of Rock Island to his shoreline land, allowing the growth of milling and manufacturing. Sears would go on to create 12 different water projects from Minnesota to Texas, as well as the village of Sears along the Rock River near Milan. (Both, courtesy of RICHS.)

Charles Atkinson

The man responsible for naming Moline was Charles Atkinson. With two names under consideration, one being Hesperia, he reportedly exclaimed, "Let it be Moline." Atkinson came to Moline from Henry County, where he founded two towns, Atkinson and Annawan. A prolific entrepreneur in Moline, Atkinson owned a sawmill, was president of the Moline Water Power Company, and founded the First National Bank. He was also instrumental in John Deere bringing his plow business to town. Atkinson persuaded the directors of the Chicago & Rock Island Railroad to route trains through Moline's industrial district instead of bypassing Moline altogether. He made three trips to Washington, DC, and convinced the government of the advantages of building a general arsenal on Rock Island. The below photograph shows the Rock Island Arsenal during World War II, at the height of its utilization. (Both, courtesy of RICHS.)

John Deere

The story of John Deere begins in Vermont in 1804. Deere's father was a tailor, and little John would help by keeping the tailoring needles polished and sharp. Raised by his mother following the death of the father when John was eight, she recognized that a man needed a special skill. Deere spent four years as an apprentice blacksmith. At 17, he hired out as a journeyman. Married at 23, Deere spent the next 10 years applying his blacksmithing skills. Competition was keen, but Deere kept busy. A series of setbacks, including debt, declining Vermont crop yields and land values, and a collapsing national banking system, sent Deere west. He left his family in Vermont in 1837 and settled in Grand Detour, Illinois, renting some land near the river and setting up a small shop.

Eastern farmers who had moved to Illinois had trouble breaking the prairie sod. Cast-iron plows that worked well back east fared poorly in the sticky Midwestern soil. Soil stuck to the plow and had to be removed by hand every few feet. Perhaps due to his early work polishing needles, or his polishing the tines of hay forks, Deere realized that a highly polished plow could clean itself as it moved through the sticky soil. Using an old sawblade, Deere fashioned the world's first successful steel plow. He soon came to the realization that his success would be in the plow business, not as a blacksmith.

In 1848, Deere moved his family and operations to Moline to take advantage of Mississippi River waterpower and better transportation. Within three years, he was producing 1,600 plows a year and buying steel to his own specifications. In these early years, Deere established the principles that still hold true today, including an insistence on standards of high quality.

Knowing that he lacked certain skills, especially in the ways of finance, Deere made sure his son Charles received the formal education he did not have. Charles joined the company in 1853 and earned a reputation as a keen businessman. By 1858, John Deere turned over the firm's management to Charles, 21. Under Charles, the firm continued to grow, giving John time to devote to social causes, provide generous contributions to local educational, charitable, and religious organizations, and become the second mayor of Moline. John Deere died on May 17, 1886, at the age of 82. (Courtesy of the William Butterworth Foundation.)

CHAPTER ONE: PATRIARCHS AND PIONEERS

John Gould
Having moved west from Vermont, John Gould became acquainted with John Deere in Grand Detour, Illinois. After Deere relocated to Moline in 1848, Gould joined the plow-making partnership of Deere, Tate, & Gould as the financial manager. Wanting to become a manufacturer himself, Gould left the firm and formed a partnership with DeWitt Dimock to produce woodenware. By 1868, the two men incorporated as Dimock, Gould & Company, adding lumber and wood-pail manufacturing. By 1890, the company owned extensive timberlands and turned exclusively to the lumber business, which continued for the next 100 years. In addition to this enterprise, Gould was responsible for bringing the first telegraph service to Moline, founded a bank, organized the Moline Water Power Company, was a director of the forerunner of the Chicago, Burlington & Quincy Railroad, and fathered the city hospital. (Both, courtesy of RICHS.)

DeWitt Dimock

Born in Connecticut, DeWitt Dimock arrived in Moline in 1843 at the age of 23. He started a small furniture manufacturer and, in 1868, formed a partnership with his brother-in-law John Gould to make furniture and woodenware. The partnership was known as Dimock, Gould & Company. The two men entered the banking business in 1857 as Gould, Dimock & Company and, six years later, chartered the bank as First National Bank of Moline. Dimock was president of the lumber firm from 1869 to 1884, retiring from the position due to ill health but retaining the title of treasurer. Dimock was a founding member of the Mississippi River Logging Company. That firm was created to float logs down the river from Dimock and Gould's timberlands in Wisconsin. The logs were then kept in holding pens until needed for milling operations. (Both, courtesy of RICHS.)

CHAPTER ONE: PATRIARCHS AND PIONEERS

Jerman Keator
One of the earliest large-scale sawmill operations in Moline was the Keator Sawmill, opened in 1856. An adjunct sash and door mill was built in 1857, but it was destroyed by fire in 1861. In 1870, the main mill burned to the ground and a larger one took its place, indicated as No. 17 in the image at right. Fire took it and 10 million feet of seasoned lumber in 1883. Now out of the lumber business, Jerman Keator became the first president of the First National Bank and built the Keator House, Moline's first modern hotel. Turning to public service, he was a member of the first city council, a member of the Moline Board of Education, and served on the Riverside Cemetery Board, voting to purchase the land that would allow expansion. He was also a major contributor to the First Congregational Church. (Both, courtesy of RICHS.)

Charles Deere

As second son of John Deere, Charles Deere was not expected to someday head the company. Fate intervened with the sudden death of older brother Francis Deere, and Charles had to quickly learn about business. He graduated from business college at 16 and joined Deere & Company as a bookkeeper. Charles quickly advanced to head salesman and enjoyed traveling the country to demonstrate Deere plows to potential customers. During the financial panic of 1857, the Deere firm ran into its own problems with cash flow and large bills for raw materials, nearly going bankrupt. Although John Deere remained president until his death, management was turned over to 21-year-old Charles, in whose hands it would rest for the next 46 years. Researchers note that Charles deserves the credit for the financial recovery and even the survival of Deere & Company. Once he put the company's financial house in order, Charles created a branch-house system that made marketing much more responsible to the customer. It allowed for better communication on customers' needs and wants and allowed for better inventory control for the wholesalers. He also developed a benefit program for employees that was somewhat rare—almost paternalistic—for the times. Should an employee be injured on the job, the company was generous in aid and compensation for the employee in an era before workers' compensation laws. Charles was considered a good leader; capable in the many areas of the firm's businesses and a tough competitor. At the time of his death in 1907, the company was making over 300 models of plows, over 150 cultivator types, corn and cotton planters, a variety of other implements, and was one of the country's major agriculture-implement manufacturers.

Beyond the Deere firm, Charles was president of the state board of labor statistics under two governors, a trustee of the DeKalb Normal School, and commissioner to the Vienna Exposition and the World's Columbian Exposition. He was extremely interested in the development of deep waterways and was appointed to be the commissioner of the Illinois and Michigan Canal for his influence in promoting national waterways before Congress. (Courtesy of William Butterworth Trust.)

CHAPTER ONE: PATRIARCHS AND PIONEERS

William LeBaron Jenny
William Jenny was not from Moline and may have only visited once. He was born in Massachusetts and educated in engineering and architecture. In 1867, Jenny opened an office in Chicago to specialize in commercial buildings and urban planning. Called the "father of the skyscraper," Jenny designed the first 10-story building, in 1885, using metal beams and columns instead of stone and brick. In 1874, Jenny made his first foray into cemetery planning in Moline. Hired to harmonize the old lower burial grounds with a new purchase of flat and hilly land, Jenny created gravesites on terraced hillsides, with curving drives and irregular-shaped burial lots. In the open flatland between the two burial grounds, Jenny designed a pleasant area called "the Green" and added a lake. Today, the Green, known as Riverside Park, contains ball diamonds, tennis courts, and a swimming pool. (Both, courtesy of RICHS.)

Dr. Jacob Stewart

Generations of locals have probably never heard of Stewartville, despite having lived there or traveled through it daily. The name has long since passed into history, yet many of its homes and some buildings have survived. The map (above) gives a reference to Stewartville's boundaries, with streets and several former and current buildings indicated. Dr. Jacob Stewart, a homeopathic physician, arrived in Moline in 1871 to set up a practice. He purchased and then developed 90 acres of land south of town and provided generous financing for both residential and commercial land, targeted to people of modest incomes. Along with the homes, the area soon acquired its own school, post office, town hall, and businesses. In 1896, Stewartville was annexed into a growing Moline, and the city's first suburb began its journey into anonymity. (Above, courtesy of Dr. Curtis Roseman; below, courtesy of RICHS.)

CHAPTER ONE: PATRIARCHS AND PIONEERS

Mary Stewart

Mary Stewart came to Moline in 1871 with her husband, Jacob. He was the doctor who created the community of Stewartville just south of Moline. With time to devote to something meaningful, and deeply opposed to the use of alcohol, Stewart and four like-minded women formed the Moline Women's Total Abstinence League. The women worked hard, but they realized that, unless women could vote, there could be no change. Stewart and other league members became suffragettes. In addition to her temperance and suffrage work, Stewart created a memorial to her husband. In 1900, Stewart's husband died in a sanitarium run by the Seventh-day Adventists. When the Adventists appealed for funds to enlarge their sanitarium, an impressed Mary Stewart purchased a former mansion at Twelfth Avenue and Fifteenth Street (above) and donated it to that group. (Both, courtesy of RICHS.)

Herman Barnard

Barnard loved anything mechanical. After learning how to be a millwright, he came to Moline to work for John Deere's company. While at Deere, he invented a wood-bending machine that made oaken plow handles. Wanting to operate his own company, Barnard began manufacturing furniture, but he shifted into mill and grain elevator equipment and made the first roller mills in the United States. He and partner Silas Leas continued to expand the Barnard & Leas Manufacturing Company (below). Now successful, Barnard built a 20-room house on 25 acres, complete with tennis courts and a pond. While undergoing a remodeling, the house was destroyed by fire. It has been written that Barnard despised all forms of pretentiousness and class distinction. If true, one might wonder why he built such a home on land that, today, is known as Barnard Court. (Both, courtesy of RICHS.)

George Stephens

Born in Pennsylvania and knowledgeable as a millwright, George Stephens built or managed mills until coming to Moline in 1843. Here, he leased, then purchased, a sawmill on Rock Island and became successful in the lumber and furniture business. When the government took over the island, it bought him out. With money from that sale, Stephens became an investor and officer in the Moline Plow Company. That firm became one of the Deere firm's biggest competitors. With the death of one of Moline Plow's partners in 1882, Stephens became the controlling owner and president. Under his guidance, the branch-house system of selling products was implemented, and profits jumped. Besides competing directly with Deere, the company also manufactured the Stephens automobile for eight years. Through a series of mergers, the company became known as Minneapolis-Moline in 1929. (Both, courtesy of RICHS.)

Robert Meyer, MD

Physician, coroner, fruit farmer, inventor, and civic leader are all words describing Dr. Robert Meyer. After studying medicine in the office of a Moline physician, Meyer graduated from Rush Medical College in 1892. He opened his office in Moline and spent the next 42 years attending to the needs of the sick. During this period, he operated a fruit farm and invented an extremely compact surgical-instrument case. Meyer's civic work included organizing the Moline Democratic Club, serving as coroner for four years, and being overseer of the poor in the city. He was a committee member that brought to Watertown the Northwestern Illinois State Hospital for the Insane, later known as the East Moline State Hospital (below). Earlier outbid by other communities, Meyer secured increases from those who had already pledged money to the project. (Both, courtesy of RICHS.)

James Pearson
Born in Sweden, James Pearson came to Moline at the age of 17. He and two partners began harvesting natural ice from the Mississippi River and created the Moline Channel Ice Company in 1892. Since the ice business was seasonal, Pearson purchased a stand of lumber and cut cord wood, which started the company in the fuel business. In the late 1890s, Pearson purchased a steamboat and entered the river sand business, creating the Moline Sand Company. That company expanded into lime, cement, and other building products. In 1907, the two companies were merged into Moline Consumers Company. By the time Pearson retired in 1941, Moline Consumers owned quarries, sand and gravel plants, and a ready-mix concrete operation. The company later expanded to numerous operations in Illinois, Missouri, and Iowa. The firm, now known as River Stone Group, deals in aggregate production. (Both, courtesy of RICHS.)

Alexander Montgomery

Alexander, Robert, James, and Samuel Montgomery started a machine shop in 1892 and shared space with a small elevator company. That same year, the brothers purchased the elevator firm, and Alexander founded the Moline Elevator Company and merged it with their machine shop. Otis Elevator purchased controlling stock and moved operations to Quincy, Illinois, in 1910. Alexander (depicted left) remained in Moline, restarted Montgomery Elevator Company, and incorporated it in 1913. Over the years, Montgomery grew to become the fourth-largest elevator company in the United States. Its most unique elevator is the tram in St. Louis's Gateway Arch. Finland's Kone purchased Montgomery Elevator in 1996. Below, employees pose in the late 1890s. Included in the first row are Alexander (far left), James (second from left), and Robert Montgomery (sixth from left). Samuel Montgomery is in the third row, fifth from left. (Left, courtesy of MDPC; below, courtesy of Mrs. A.S. Benson.)

Edward Coryn
Born in Lotenhulle, East Flanders, Belgium, in 1857, Edward Coryn immigrated to Moline with his parents in 1880. Already skilled in the Flemish and French languages, he became fluent in English, as well. He worked as a factory laborer and then opened a grocery store. After 14 years at the grocery, Coryn sold it to his employees and became the manager of the Moline Trust Savings Bank. Within a month, he was named a vice president of the bank. He was also an officer of the Moline Incandescent Lamp Company and part owner of an office building and a popular department store.

While he was certainly a prosperous businessman, Coryn was most noted for his public service. From the late 1800s to the early 1900s, Moline had the largest population of Belgians of any area in the United States. Coryn aided many of those arriving Belgians in finding places to live and work. He was the main organizer of the Belgian Working Men's Union, which offered working families with benefits when they became ill. He founded the Belgian-American Club to provide a social outlet for his countrymen. The club also arranged for English-language and civics classes to help the immigrants in their efforts toward becoming American citizens. Coryn was one of the founders of the weekly Flemish-language newspaper *Gazette Van Moline*, which covered news of the homeland and other Belgian settlements in the United States and Canada. He was successful in petitioning the Peoria Diocese for the establishment of a Belgian church in Moline. Coryn was the first president of the National Belgian-American Alliance, a federation of Belgian American organizations, to assist not only immigrants but also their family members in occupied Belgium during World War I. For his service and contributions to his countrymen, Coryn was awarded the Knight's Cross of the Order of Leopold and was made Moline's first honorary consul of Belgium.

With a deep interest in his adopted country, Coryn entered politics and was elected alderman. He held that position for eight years. From 1914 to 1916, Coryn served as Moline postmaster. In 1971, on the 50th anniversary of his death, a memorial plaque was placed at the municipal school of Lotenhulle to honor native son Edward Coryn for his life's work and service to the Belgian community in Moline. (Courtesy of the Center for Belgian Culture.)

Frank G. Allen

Following graduation from the University of Michigan, Frank Allen came to Moline and joined the Moline Plow Company. His marriage to owner George W. Stephens's daughter Minnie in 1891 was somewhat advantageous, as Allen was named a comanager of the firm that same year. Allen proved knowledgeable in the business, as it was he and Stephens who created Moline Plow's branch system, which produced greater sales and profits. Following Stephens's death in 1901, Allen became president and general manager of the firm. That position offered philanthropic opportunities for both he and his wife. The couple's largest gift to Moline was their home, Allendale. It was gifted to the school system in 1931 and has been used ever since as its administrative offices. For a brief period, some classes of the nearby high school were held in the building. (Both, courtesy of RICHS.)

Vincent Bendix

Born in Moline to the son of a minister, Vincent Bendix ran away to New York City at 16. He held a variety of jobs while he studied engineering at night school. Returning to Chicago in 1907, Bendix designed the Bendix Motor Buggy and sold over 5,000 of them before the venture went bankrupt. In 1910, he received a patent for his invention of a mechanical drive that made automobile self-starting practical. Creating a number of companies, Bendix produced the first practical four-wheel automotive brake system and the pressure carburetor for airplanes, as well as marine, radio, radar, and other automotive and aviation equipment. His interest in promoting aviation led to his founding of the Bendix Transcontinental Air Race in 1931. He is seen in the below photograph with 1936 Bendix Race winners Louise Fahden (left) and Blanche Noyes. (Left, courtesy of Automotive Hall of Fame; below, courtesy of Quad City International Airport.)

Mattie Poole

One of Moline's earliest businesswomen was Mattie Poole. In the late 1890s, she opened an art store and studio selling decorated china she had painted herself. Critics noted that her work showed a delicacy and shading not found in the typical painting of the day. She also taught china painting; as her renown grew, students flocked to her studio to learn her technique. Poole's success was so great that, by 1912, she had generated enough wealth to construct a building on Fifth Avenue to house her shop and some apartments. Business continued to grow rapidly, and Poole hired some of her better students to help paint china to order. She only hired women and paid them a fair wage. The below photograph shows examples of her finely painted china product. The store closed in 1948 with Mattie Poole's death. (Right, courtesy of Greg Witte; below, courtesy of RICHS.)

Willard Velie Sr.
Velie was corporate secretary and a member of Deere & Company's board of directors. Driven by ambition, he founded the Velie Carriage Company to make quality carriages and wagons. In 1908, Velie was elected vice president of the Deere firm. Over the course of the next eight years, Velie created the Velie Motor Company to produce engines and manufacture automobiles. He resigned his executive positions with Deere in 1918. In 1927, his son Willard Velie Jr. brought airplane manufacturing into the fold. Velie Motor purchased a local aircraft business in early 1928, naming it Mono Aircraft. The plane was fast, affordable, and it won many air races. Plans to create a four-passenger model never came to fruition, as Willard Velie Sr. died in October 1928. Automobile production was halted in November; four months later, Willard Jr. died. (Both, courtesy of RICHS.)

Charles Borg and Marshall Beck
Already an accomplished carpenter and furniture maker, Charles Borg (above, left) was hired by Deere & Company to shape wagon tongues. To replace the manual labor of that task, Borg created a machine to form the tongues in one operation. With the success of that machine, Charles and lawyer friend Marshall Beck (above, right) founded Borg & Beck Company in 1903 to develop additional automated woodworking equipment. Known for its quality, Borg & Beck also began machining automobile parts. This led Borg's son George, Beck, and shop foreman Gust Nelson to develop the first practical sliding clutch assembly for automobiles (below). Clutch production was moved to a larger factory in Chicago to meet demand. In 1923, both Charles Borg and Marshall Beck sold their interests in the company. George Borg would merge Borg & Beck with four other parts firms in 1928 to create Borg-Warner Automotive. (Both, courtesy of RICHS.)

Eldorado Jones
Earlier in her life, Eldorado Jones (above, right) sold life insurance and taught school. Unfulfilled in either job, she turned to inventing and became successful. She held patents for collapsible hat racks, anti-damp salt shakers, and her most popular creation, a lightweight electric iron. Several hundred thousand irons were manufactured in Moline by only women over 40 years of age. Jones hired only women, as she felt men were mean, mercenary, and avaricious. They controlled everything. No doubt that is why her best invention never saw success. During World War I, she invented a muffler for aircraft similar to the plane shown below. The muffler cut down on noise and even improved gas mileage, but Jones could not get it approved in an official aircraft test. Bitter, she moved to New York, where she died penniless. (Both, courtesy of RICHS.)

Gustaf DeSchepper
An early immigrant to Moline from Belgium, Gustaf DeSchepper took a ride from one of the many barnstorming aviators who frequented the flat fields of Moline. He fell in love with aviation and began taking flying lessons on Credit Island in Davenport, Iowa. He became the first Moline resident to receive a private pilot's license. Realizing the need for an airfield on the Moline side of the river, he became the driving force in the development and operation of Moline's first airport. DeSchepper rented part of a farm south of Rock River, and Franing Field was born. He and Earl Campbell formed the Campbell-DeSchepper Airplane Company and brought the National Air Tour to Moline four times in seven years. Franing Field is seen below with its grass runways and early hangar buildings about 1925. (Both, courtesy of the Quad City International Airport.)

Earl Campbell
When some people think of Moline and airplanes, the name Earl Campbell comes to mind. He was one of the city's earliest aviators. Campbell was not only important in airport development, but he advocated for the National Air Tour to make stops in Moline. More important, it was through his diligent efforts that National Air Transport (NAT) established an airmail route through Moline in 1926. His Campbell-DeSchepper Airplane Company waived field-usage fees and supplied hangar space and mechanics for the airline. As seen below, Campbell also served as a substitute pilot when needed. NAT was the predecessor to United Airlines, the first passenger airline to service Moline. United served Moline as a mainline route for 60 years until it replaced the larger planes with regional jet service under the name United Express. (Both, courtesy of Quad City International Airport.)

Severin Seaberg
Swedish immigrant Severin Seaberg arrived in Moline in 1896. He held several jobs, including manager of the Standard Calorimeter Company. He grew that company from a single employee to 53. In 1922, he manufactured a fire-alarm box developed by Frederick Harrington, and the two became partners in the Harrington-Seaberg Machine & Electric Company. That year, the firm installed traffic signals in the Chicago Loop, followed by signals for Los Angeles in 1923. The company was renamed Harrington-Seaberg Corporation in 1923 and manufactured traffic signals and fire-alarm telegraphs. Just before the Depression, the firm became a unit of the Gamewell Company, with Seaberg becoming its general manager. Harrington went on to form his own company. The new unit became Eagle Signal and produced traffic signals, fire alarms, and timers sold worldwide. Severin Seaberg is seen at far right in the below photograph. (Both, courtesy of George Seaberg.)

Frederick Lundahl
Moline Pressed Steel Company supplied parts to various industries and the military. Owner Frederick Lundahl noticed that, as his son Arthur became older, stronger, and more active, his toys seemed less durable. Frederick began making toys from scraps of steel and bringing them home for Arthur, known as "Buddy L.," to play with. Other neighborhood children liked the toys, as well. During a slump year for a customer, Lundahl modeled a truck he hoped to sell to that customer, but was turned down. Several department stores showed no interest, but one buyer saw Lundahl standing on his sample with no ill effect on the toy and purchased all that Lundahl could produce. Buddy L Toys was born. By 1926, Moline Pressed Steel was manufacturing only quality metal toys that worked and lasted. They are highly sought after today. (Both, courtesy of the Lundahl family.)

Frederick Harrington

Harrington, seen on the right in the above photograph, originally partnered with Severin Seaberg in the Harrington-Seaberg Corporation. The company designed municipal signaling systems for traffic, fire, and police departments. In 1929, the company became part of the Gamewell Corporation, with Seaberg joining that firm. Harrington created Harrington Signal Company and concentrated on police and fire alarms. Some residents may remember the large red boxes on posts and walls. When a cover was lifted and a lever pulled, it sent a telegraph signal to the local firehouses. The telegraph punched a paper strip; by reading the punches and spacing between, firemen determined the location of the alarm box. Before two-way radios came into wide use, a policeman would check in with headquarters or call for assistance (below). (Above, courtesy of Don Oppenheimer; below, courtesy of the Moline Police Department.)

The Moline Automobile

Orlando Root and William Van Dervoort created Root & Van Dervoort Engineering Company in 1900 to produce stationary gasoline engines. In 1904, the company created the Moline Automobile Company to manufacture the "Moline" automobile. Ironically, the firm was located in East Moline. The Moline gained wide-spread popularity, and, in 1913, the firm was granted a license to use a new, more-powerful engine design. The car would now be known as the Moline Knight. Shown below is the Moline Knight Touring Car. During World War I, Root & Van Dervoort produced munitions and armament for Britain and the United States. Following the war, automobile production of the Moline Knight was integrated with the engineering company, and the car became known as the R&V Knight. Still a quality vehicle, production ended in 1924, when the company went into receivership. (Both, courtesy of RICHS.)

Phoebe Omlie

Moline's Mono Aircraft Company gained strong sales, thanks to the winning reputation of its airplanes. Phoebe Omlie won many air races and set numerous flying records in her Velie Monocoupe. She was the first woman in the country to earn a transport pilot's license and the first to receive an aircraft mechanic's license. She set a world's altitude record for females, at 25,400 feet over Moline, in her airplane, *Miss Moline* (above). She was the first female appointed to a federal aviation position. Omlie was also a member of the Mono Aircraft Company racing team. Regional and national air races were constantly being won by members of the company team. Members of the late-1920s team are shown below. They are, from left to right, manager Vern Roberts, Omlie, Roy "Stub" Quimby, John Hinchey, and John Livingston. (Above, courtesy of Quad City International Airport; below, courtesy of Ken Roberts.)

CHAPTER TWO

Community Leaders, Interesting Deeds

Early Moline was created by entrepreneurs who saw a need and filled it. They set a creative tone that continued well into the 20th century. Each successive generation added to the businesses, allowing Moline to grow larger and stronger. John Trevor is the fourth generation of the family to operate Trevor Hardware. Lagomarcino Soda & Candy is in its second century years of operation. Jon and Jeff Tunberg continue Whitey's Ice Cream, founded in the 1930s.

In addition to the business owners and shopkeepers, others have contributed to Moline's growth through their public service. Theodore Wharton created a financial plan that allowed the construction of the public schools' field house. Teacher Stanley Leach served many youth-related groups and was Moline's longest-serving mayor. William Coopman Jr. turned his professional knowledge into assisting a public radio station with its engineering needs. Barbara Sandberg has devoted thousands of hours to historic preservation.

Others, through their philanthropy, made the Moline area a better place. Katherine Butterworth and Patricia Wiman both offered their homes and grounds so that nonprofit organizations would have a place to meet. Businessman Arvid Kohler contributed millions to save a zoo.

There is still one other group of people that has helped make Moline the city it is; those with interesting backgrounds and fascinating stories—the kind of stories people relate to their friends and families, giving Moline its interesting character. Sgt. John Baker was awarded the Congressional Medal of Honor; Ann Richie was a former slave; and William Blaser was the last Edsel automobile dealer. They are as much a part of the community's leadership as the businessman, the public servant, and the philanthropist.

William Meese

William Meese was admitted to the bar in Rock Island County in 1878. He had a wide range of interests, but was most known for activities in history, law, and politics. Meese had one of the best private libraries on Illinois history, so it is appropriate that he founded the Rock Island County Historical Society in 1905 and was its president until 1914. The society had three goals: to study and learn; to collect and preserve; and to disseminate the history of the county. Through the efforts of Meese, Congress appropriated money for the construction of the Moline Lock, giving the city a harbor. He was also responsible for the Campbell's Island State Memorial. Shown below is today's home for the Rock Island County Historical Society. The home was donated in 1962, and the library wing on the right was added in 1992. (Right, courtesy of RICHS; below, courtesy of Diann Moore.)

CHAPTER TWO: COMMUNITY LEADERS, INTERESTING DEEDS

Trevor Hardware
A family-owned business for 128 years, Trevor Hardware is the last of the real hardware stores left in Moline. The proprietors will still sell a customer just one nail or hex nut. When the store opened in 1887 as Glenn & Trevor Hardware, it was located in what was then the Stewartville town hall. In 1900, it moved across Sixteenth Street to the store shown above. The store originally offered farm implements, but those items were phased out in favor of the needs of a growing urban population. A new store was built a few blocks south in the late 1970s to provide room for more products and services. Fourth-generation owner John "Butch" Trevor, seen on the far right in the below photograph, continues with competitive pricing and personal customer service not found in today's large home centers. (Above, courtesy of Trevor Hardware; below, courtesy of the author.)

George Benjamin Wittick

Born in Pennsylvania in 1845, George Wittick came to Moline with his parents when he was nine years old. At age 16, he fought for a year in the Civil War and then joined the 2nd Minnesota Mounted Rangers to fight the Dakota Sioux. Returning to Moline with a new wife, he opened a photography studio. He enjoyed the work but not the subject matter. After fighting the Sioux, he wanted to photograph Native Americans and their culture. He left his wife and six children in Moline and became the photographer for the Atlantic & Pacific Railroad in New Mexico. He spent five years with the railroad and then set up studios in various Southwest towns, taking portraits of government officials, settlers, and Native Americans like Geronimo (right). Wittick died from a rattlesnake bite in 1903. (Both, courtesy of RICHS.)

William Schulzke

Perhaps the most prolific architect in Moline was William Schulzke. A graduate of the University of Illinois, he became a partner with fellow university alumnus Hammond Whitsitt in the firm Whitsitt & Schulzke in 1914. The firm was responsible for designing many commercial buildings, factories, schools, and churches throughout the Midwest. The firm pioneered the use of poured concrete in the outer structure of home construction. Schulzke was responsible for the design of the Fifth Avenue Building, Moline Elks Club (below), Scottish Rite Cathedral, Wharton Field House, the original buildings of the Moline Airport, as well as its 1939 terminal-hangar building, and the post office building. Not afraid to try new ideas, one of Schulzke's designs was crafted from emulsified asphalt block, the only such building in the country. It lasted over 30 years before being torn down for redevelopment. (Both, courtesy of RICHS.)

Caldwell Rosborough

Moline Tool Company was founded in 1901 and became famous for its "Hole Hog" line of multi-spindle boring and milling machinery. The firm was acquired by Caldwell Rosborough in 1926. In the below photograph, Rosborough (seated, center) is shown with his sons, clockwise from left, William, Joseph, and James, all officers of the firm. But the machine-tool industry could be seen as a sideline for the men, as each was highly involved in public service. Caldwell served the Moline School Board for 30 years, 19 years as president. He was also head of the chamber of commerce aviation committee, helping establish the Moline airport as the area's air-carrier facility. James was involved with the Red Cross and served as an original guiding member of the Civic Center Authority board. Joseph was a longtime officer of the county historical society, and William was heavily involved with the Moline Rotary. (Both, courtesy of Bobby Jo Irish.)

Thomas Lagomarcino Sr.

In 1908, Angelo and Luiga Lagomarcino arrived in Moline and opened a little store to sell candy, ice cream, fruit, and tobacco. Their children helped around the shop. Son Thomas (above) took over the family business, and Lago's became an institution. Along with his wife, Betsy, Thomas Lagomarcino continued to provide fancy fruit baskets and hand-dipped chocolates and serve up homemade ice cream at what national magazines proclaim is "the best soda fountain in the US." And it would be hard to dispute that reputation. While the original store remains, another location was opened in Davenport, Iowa, to meet demand. Shown below are three of the Lagomarcino children, Beth (left), Tom Jr. (center), and Lisa. They returned from college and other careers to continue the institution. In 2008, Lago's was recognized by the James Beard Foundation as "America's Classic." The award is considered the "Oscar of the food industry." (Both, courtesy of Lagomarcino's.)

Earl Wendt III

Wendt Funeral Home was founded in 1866 in Port Byron, Illinois, and has been located in Moline since 1929. Earl "Buck" Wendt began handling funeral business with his uncle following the death of his father in 1967. He took over ownership in 1985 and was joined by his son Earl Wendt IV in 1977. An early horse-drawn Wendt hearse is seen above in one of the many 1948 Moline centennial parades. Very active in Republican politics, "Buck" Wendt served as a city councilman from 1969 to 1973 and mayor from 1973 to 1977. Although criticized at times for his efforts to rid the city of its more undesirable elements, those efforts did have results on much of the questionable and illegal activity. Below, Mayor Wendt (right) meets newly elected Illinois governor James Thompson. (Above, courtesy of RICHS; left, courtesy of Earl Wendt III.)

G. LaVerne Flambo

He wanted to be an opera singer and even won a national radio talent audition. But G. LaVerne Flambo found there was not much demand for opera singers. So, instead, he sold paint in Fairfield, Iowa. While in Fairfield, he began booking musical and dramatic shows into area theaters. In 1948, he joined Moline radio station WQUA as vice president and continued to bring big-name artists to area stages. Flambo booked the very popular McGuire Sisters (below) for a week of shows at the Quad City Autorama. Their fee was $8,000. He offered a guarantee of $6,000 and 60 percent of ticket sales, which they turned down. Had they accepted his offer, the McGuires would have pocketed $20,000. He definitely knew his audience, as nearly 45,000 people were drawn to the show that year. Flambo was the consummate businessman, impresario, and civic leader until his death in 1977. (Both, courtesy of John Flambo.)

Robert Tunberg

It is rare for a teenager to go to work during high school and wind up owning the business. Robert Tunberg did. Whitey's Ice Cream was established by Chester "Whitey" Lindgren in 1933. Tunberg was hired two years later and worked there throughout high school. In 1953, Robert and his wife, Norma, purchased the store. Since 1977, the business has grown, with multiple locations and distribution to grocery stores across the Midwest. It has been named "Best in the Midwest" by *Midwest Living* magazine and tops the list of "World's Best Ice Cream" by *Condé Nast Traveler*. In the above photograph, Robert Tunberg (right) demonstrates to Chester Lindgren exactly how thick Whitey's shakes are. Norma and Robert are seen below on a well-deserved vacation. Quality products, pristine stores, and excellent customer service are hallmarks of Whitey's Ice Cream. (Both, courtesy of Jon and Jeff Tunberg.)

CHAPTER TWO: COMMUNITY LEADERS, INTERESTING DEEDS

Earl Beling

When many residents hear the name Beling, they may think of the former Moline High School building he purchased as headquarters for his engineering firm. Behind the scenes, those residents would find that Earl Beling had a long list of contributions to civic organizations. He spent eleven years on the Moline Board of Education and served six years as its president. He was one of the organizers of the Moline Music Guild and served as president of that group for 20 years. His purchase of the old high school building not only served his company, Beling Engineering, but offered nonprofit organizations space at little cost. When firms and stores were leaving downtown, he became president of First Moline Neighborhood Redevelopment Corporation to find revitalization opportunities. Above, Beling and his wife, Lucille, pose at Christmas in 1971. (Both, courtesy of MDPC.)

49

Robert Bartel

A drag race is the perfect means to find out who has the fastest hot rod. But in the early 1950s, the only place to race in Moline was on the streets. That changed in 1955, when Robert Bartel, Ken Roberts, and Keith Cordell set out to build a track specifically for drag racing. Property was purchased near Cordova and became the home of the Quad City Dragway, the first purpose-built track in the country. A national meet called the World Series was moved to the track in 1957 and has been there ever since. It is the oldest continual race in the country. The view of the 1962 World Series (below) attests to its popularity. Bartel managed the facility until he retired in 1985. His legacy includes establishing many safety rules, being the first to pay award money, and helping to establish the careers of many top racing stars. (Left, courtesy of the author; below, courtesy of Ken Roberts.)

Leonard Hawk

A tenor in the Moline High choir, Leonard Hawk decided he wanted to be a professional singer. But this did not come to be. He sold radio time and Yellow Pages advertising, then discovered the rental business. Hawk opened a franchise rental store in Moline in 1954. One year later, unhappy with the service and the charges of his franchiser, Hawk arranged for a meeting with other dissatisfied franchisees. That meeting resulted in today's American Rental Association (ARA), an international trade group for equipment-rental companies. It has been headquartered in Moline since 1955. As a founder and the first president of ARA, Hawk is credited with giving rental-store owners representation in the industry. Hawk retired from his A-1 Rental stores, but his son Mark followed in his father's footsteps with his own store, AAA Rents. (Above, courtesy of Leonard Hawk; below, courtesy of the author.)

William Blaser

As World War II was coming to an end, William Blaser began selling used automobiles. When the war ended, he and his son were awarded a Nash franchise. Above, Blaser (center) and son Stewart (left) pose with an unidentified salesman and a new Nash. In 1956, Ford Motor Company offered the Blasers an exclusive Edsel dealership. The Nash franchise was canceled, and Blaser Auto Sales introduced the new Edsel with great excitement. That excitement would not last long. The 1958 Edsel, introduced in 1957, had many quality problems, and its styling dismayed prospective buyers. Many of these concerns had been worked out by the 1959 model year, but the damage had been done. Ford Motor Company began terminating the dealerships. Blaser Auto settled with Ford at the end of 1959, becoming the last Edsel dealer in America. (Both, courtesy of Steve Blaser.)

Sgt. John Baker

Many classmates remember John Baker as a good gymnast. And residents know Sgt. Baker as a Congressional Medal of Honor recipient for his valor during the Vietnam War. In late 1966, his infantry company was sent to rescue another company trapped by the enemy. As rescue efforts began, the lead man was killed. Baker and two others took the lead, and he assisted in neutralizing two enemy bunkers. The trio was moving toward another enemy position when the other two soldiers were injured. Baker single-handedly destroyed another bunker before retrieving his wounded comrades. Taking further fire from bunkers and snipers, he continued to retrieve wounded and obtain ammunition. In addition to saving the lives of eight fellow soldiers, Baker was credited with destroying six Viet Cong bunkers and killing 10 enemy soldiers. Pres. Lyndon Johnson presented Sgt. Baker the Medal of Honor on May 1, 1968. (Both, courtesy of Chapter 299 Vietnam Veterans of America.)

Rev. John Culemans

In 1906, Bishop John Spalding assigned newly ordained priest John Culemans the task of forming a new Catholic parish in Moline to serve its large Flemish-speaking population of Belgian immigrants. Rev. Culemans, an immigrant Belgian himself, launched Sacred Heart Parish. A church was built, and a school soon followed. Growth of the congregation necessitated a larger, cathedral-style building (right) in 1916. To further serve his growing flock, Rev. Culemans was instrumental in creating the Flemish-language newspaper *Gazette Van Moline*. Bitten by the aviation bug, he earned a pilot's license and was nicknamed "the flying priest." He wrote articles touting the benefits of aviation and was named head of the chamber of commerce aviation committee. His parishioners purchased Culemans a new plane after his was destroyed in a hangar fire. (Both, courtesy of Sacred Heart Church.)

Katherine Butterworth

The youngest daughter of Charles Deere and a granddaughter of John Deere, Katherine Deere married William Butterworth in 1892. After their honeymoon in Europe, the couple returned to Moline. They moved into their new home (below), built by Katherine's father as a wedding gift. William joined the Deere firm that same year. He became president in 1907 and chairman in 1928. The Butterworths lived well during prosperous times, and they gave generously to worthy institutions and organizations. When her husband died in 1936, Katherine established the William Butterworth Foundation. When she died, her home, now tripled in size from the original structure and occupying one square block, was willed to the foundation to be used as a civic center to promote cultural and educational activities. The Butterworth Center provides free meeting space for over 1,300 not-for-profit meetings each year. It is one of Moline's crown jewels. (Both, courtesy of the William Butterworth Foundation.)

Rev. Robert E. Lee
"How can an Irish kid minister to a group of older Belgians?" thought Rev. Robert E. Lee when he was assigned as an assistant pastor at Sacred Heart Parish immediately after his ordination in 1959. Whatever misgivings he had then, it all worked for the best, as he spent the next 17 years as an assistant at Sacred Heart. In 1976, he was appointed pastor at Moline's St. Mary's Parish, but he returned to Sacred Heart four years later as its pastor. Regardless of which church he was at, Rev. Lee poured himself into serving the needs of his parishioners. Known for a practical approach to issues of faith, he put the answers to the problems brought to him in the simplest of terms. So compassionate and understanding of the failings of humans, Rev. Lee was sought out for his advice by people of all faiths.

Lee was not only a minister of the faith, but an educational leader, as well. He was instrumental in the consolidation of Moline's Catholic schools into the Seton Catholic elementary and middle school system. Against all advice, he recognized the need for a new middle school building. He headed the building campaign and successfully raised the $3 million needed to complete the project by emphasizing the importance of Catholic education.

It was not only Sacred Heart and the Seton school that received the benefit of Rev. Lee's advice and consul. He served the community as a member of the Black Hawk College board of trustees and sat on the board of the former Lutheran Hospital. He was a longtime member of the Moline Youth Commission, the Youth Citizens Advisory Board, and the Family Counseling Service Board. Rev. Lee served the needs of his parish and the entire community until he retired in 2001.

As often happens, though, the good die young. Rev. Lee passed away at age 74 in 2008. He was a servant of God, a mentor, community leader, and friend to thousands whose lives he touched through his priestly duties, public service, and his magnetic personality. (Courtesy of MDPC.)

CHAPTER TWO: COMMUNITY LEADERS, INTERESTING DEEDS

Rev. R.A. Allen

The second predominantly African American church established in Moline was the Tabernacle Baptist Church. Its roots go back to the 1890s, when African Americans worshipped at various locations in the city. A more formal home was created in 1912 on Eighth Street and Sixteenth Avenue. That same year, the building was moved to Fifteenth Street and Twenty-Sixth Avenue. The building was enlarged in 1917, and the new church building (above) was erected on the property in 1967. Several pastors served the church until 1936, when Rev. R.A. Allen arrived for a 50-year tenure. Shown below with his wife Clara Belle, Rev. Allen attended the Western College and Seminary in Kansas City, Kansas, and served churches in Missouri and Wisconsin before coming to Moline. When Rev. Allen began his pastoral duties, the Tabernacle Baptist had 30 members. By 1975, the church membership had grown to 250 parishioners. (Above, courtesy of the author; left, courtesy of Rev. Melvin Grimes.)

Robert Ontiveros

Robert Ontiveros was born in the west-end Hispanic neighborhood of Moline, one of 12 brothers and sisters, and was nurtured with a strong work ethic. In 1974, he started Bi-State Packaging to supply packaging materials to industries. The company grew rapidly into other services and is known today as Group O. It is the largest Hispanic-owned business in Illinois and is among the 20 top Hispanic-owned companies in the United States. With a passion for his community and diversity promotion, Ontiveros founded the local Boys and Girls Club, and the Greater Quad City Hispanic Chamber of Commerce, and he created scholarships at four area colleges. He was named a 2013 Order of Lincoln Laureate of the Lincoln Academy (below) for his "dedication to the principles of public service." In 2008, his wife, Blenda (above, left), and Robert (right) funded construction for the Community Health Care Clinic. (Both, courtesy of Robert Ontiveros.)

Roy J. Carver

Born in Preemption, Illinois, Roy Carver graduated from Moline High School in 1927. After earning an engineering degree, Carver founded Carver Pump Company in 1938. Noted for its self-priming pumps, the company was soon supplying US and Allied forces during World War II. Needing larger production space, the company moved to Muscatine, Iowa. On a trip to Germany in 1957, Carver purchased the North American rights to a "cold" process for retreading tires and, later, the worldwide rights for the process. By the 1970s, Bandag was among the top American corporations. Success brought Carver great wealth, and he established the Roy J. Carver Charitable Trust, giving millions to the University of Iowa, Augustana College, and St. Ambrose University. Above, Carver is seen at the dedication of Augustana's Carver Center. Below, he is shown at right with John Telleen, chairman of Augustana's board. (Both, courtesy of Augustana Special Collections.)

Richard Shrader

Anyone who flew out of Moline on United Airlines between 1942 and 1980 probably recognized Richard Shrader. He began as a radio operator and retired as the sales and operations manager for United's Moline station. For brief periods, the airline had Shrader serve Cleveland, Washington, DC, and Philadelphia. He opened service at Cedar Rapids, Iowa, for United. But United Airlines was not the only thing Moliners would remember about him. Public service was part of Shrader's mission. Shrader served on the board or as officer of the Moline Jaycees, Optimist Club, Music Guild, Public Hospital, and the school board. He was a member of the chamber of commerce, Red Cross, and Rotary Club, and he was an alderman and an airport commissioner. Below, Shrader works with the airline office's reservation system in the early 1950s, long before computers took over the work. (Both, courtesy of the Shrader family.)

Margaret Giles

Margaret Giles was born in 1872 in South Moline Township. She graduated from a Chicago nursing school in 1903 and returned to Moline to practice. That same year, the Moline City Union of King's Daughters and King's Sons hired a traveling nurse to tend to the medical needs of a growing immigrant population. In 1907, Rock Island also began a program and hired Giles as its first nurse. Taking streetcars or walking, Giles made her rounds to families similar to those shown below. That first year, records show she made 1,480 calls to 194 patients. Giles announced her resignation in late 1913, as she was to be married in early 1914. Perhaps it was through her dedication to duty that she ignored her pain, but in December 1913 she died in the hospital from a ruptured appendix. (Both, courtesy of RICHS.)

Stanley Leach

After graduating college, Stanley Leach returned to Moline High School as an art teacher. His jewelry and metals class was one of the art department's most popular. But teaching seemed only a sideline, as he was dedicated to youth and volunteerism. He served on the Illinois Youth Commission, pioneered the Optimist Club's youth flag-football program, cofounded the Moline Young Life program, and chaired fundraising programs at Arrowhead Ranch. He served on many nonprofit boards and has spent over 40 years volunteering at the local PGA golf tournament. In addition to his work with youth and local philanthropies, Leach has served the city as a township trustee and alderman. In 1993, he became the first mayor of Moline elected to three consecutive terms, retiring in 2005. He is seen below in discussion with soon-to-be president Vincente Fox of Mexico (right) in 1999. (Both, courtesy of Stanley Leach.)

Theodore Wharton

Wharton was born in Ohio and grew up in Minnesota. Working for a Chicago accounting firm, Wharton was noticed by Deere & Company officials when he came to audit the firm's books. Deere hired him the following year as its comptroller, a position he held until retirement. Active in civic affairs, he served as a member of the school board for 18 years. When the school board decided to build a new athletic arena, Wharton became president of the group that raised the money for its construction. It was he who created a strategy to sell bonds to Moline residents in $100 amounts to adults and $50 amounts for Moline schoolchildren. In less than one month, the $175,000 construction cost had been raised. To honor his leadership, the field house (below) was renamed the T.F. Wharton Field House in 1941. (Left, courtesy of Richard Wharton; below, courtesy of RICHS.)

LEGENDARY LOCALS

William McAdams
William "Willie" McAdams was an all-state football player at Moline High and a 1947 graduate. Throughout his life, he has had an interest in the history of the area once known as Stewartville, the role of African Americans in the area, and Moline in general. He has served on the board of the county historical society and has compiled complete obituary records of the county's African American residents. (Courtesy of the author.)

Donald Sundquist
Sundquist graduated from Moline High in 1953. His career took him to Tennessee, where he became interested in politics and served six terms in the US House of Representatives. Sundquist went on to serve two terms as governor of Tennessee (1995–2003), focusing on government efficiency and welfare reform. His state was the first in the nation to connect all schools and libraries to the Internet. (Courtesy of Tennessee State Library and Archives.)

George Kirk

When the Metropolitan Airport Authority was created, George Kirk was its first employee, hired to manage the Quad City Airport. Perhaps this was only fitting, as Kirk was a World War II Navy ace with two Distinguished Flying Crosses and several other decorations. Kirk flew a Hellcat over the Pacific Ocean and was credited with seven victories. As manager of the airport for 29 years, he oversaw much of the initial growth and development at the airport. A new terminal and several of its additions, property expansion, longer runways, additional airline service, and completion of a new control tower all came during Kirk's tenure. Right, during the 1970 dedication of a completely rebuilt and lengthened runway, Kirk (right) points out its features to airport commissioner William Dowsett. Kirk is nationally recognized for his achievements in aviation management. (Both, courtesy of the Quad City International Airport.)

William Coopman Jr.
With an accounting degree, William Coopman Jr. went to work at Deere & Company in 1963 as a field auditor. He began examining the company's telephone usage costs, and, a few years later, he was named the first manager of telecommunications for Deere, a title he held until retirement in 2002. His department was responsible for Deere's communications and data systems' needs. Along the way, Coopman founded the Iowa Telecommunications User Group, was president of the International Communications Association, and was chairman of the International Telecommunications User Group based in Brussels, Belgium. Following retirement, Coopman has volunteered at public radio WVIK, rebuilding its reading service home receivers used by the visually impaired, as well as conducting general broadcast engineering for the station. He has also volunteered at UnityPoint Hospital and the local PGA golf tournament, and has helped immigrants develop computer skills. (Above, courtesy of *Communicatons Week*; below, courtesy of the author.)

Pattie Southall Wiman

Pattie Wiman was the wife of Charles Deere Wiman, former president of Deere & Company and a great-grandson of John Deere. Her interests included the DAR, King's Daughters and Sons, and the Moline Public Hospital. Yet, many locals are unaware of her connection to two county entities. In 1962, she purchased the former Atkinson-Peek home and gave it to the Rock Island County Historical Society as a repository for items relating to the county's history. In 1963, she purchased a former exotic animal farm and surrounding land and deeded it to the county for what would become Niabi Zoo. Upon her death in 1976, Wiman's home, originally built by John Deere's son Charles and known as the Deere-Wiman house (below), became part of the William Butterworth Foundation. It is used by nonprofit organizations for various functions. (Left, courtesy of the William Butterworth Foundation; below, courtesy of RICHS.)

Arvid Kohler

A descendant of a pioneer Moline family that came to the area in the early 1850s, Arvid Kohler served in World War II and worked at Minneapolis-Moline and later became a manufacturer's representative. In 1974, he purchased Export Packaging Company (known today as Xpac). Always a donor to area charities, his true passion was animals. He served as president of the Niabi Zoological Society from 1981 to 1985 and again from 1994 until his death in 1996. Kohler was instrumental in saving the ailing county zoo by putting his own resources and those of his company into the zoo's revitalization. His efforts to gather community support and donations truly set the zoo on the path to success. In the above photograph, Ken Johnson of Export (left) and Ted Davies of the county forest preserve (right) join Kohler in reviewing plans for a new animal exhibit. (Both, courtesy of the Kohler family.)

CHAPTER TWO: COMMUNITY LEADERS, INTERESTING DEEDS

Barbara Sandberg
When a historic 1850s mansion was demolished in 1986, despite its placement in the National Register of Historic Places, Barbara Sandberg helped organize the Moline Preservation Society. The group's mission was to make sure no other pieces of historic significance suffered the same fate. Elected to the city council in 1991, Sandberg saw plans that had many old buildings marked for demolition. She got support from other council members to save the buildings for reuse, and she became the driving force behind a preservation ordinance, the Moline Preservation Commission, and the Downtown Commercial Historic District. Through Sandberg's efforts, many of the historic buildings, like the Skinner Block (below) on John Deere Commons, have been saved and repurposed for new uses. (Left, courtesy of MDPC; below, courtesy of RICHS.)

Thomas Railsback

Moline attorney Tom Railsback was elected to the Illinois General Assembly in 1962. In 1966, he was elected to the US House of Representatives and began a 16-year tenure in Washington. A moderate, he became the second-ranking Republican on the House Judiciary Committee. He voted for one of three articles of impeachment against Pres. Richard Nixon, one of six Republicans to support at least one article of impeachment. When Nixon resigned, many considered Railsback a traitor to the Republican Party, but he was reelected by a landslide and won again three more times. He was defeated for renomination in 1982 by a more conservative candidate, perhaps because of his vote against Nixon. The below photograph, taken in the mid-1970s, shows Railsback (right) and his chief of staff Ben Polk (left) visiting with Moline mayor Earl "Buck" Wendt. (Above, courtesy of RICHS; below, courtesy of Earl Wendt.)

William Fisher

Hundreds of children attending Moline elementary schools might remember William Fisher as the friendly policeman who taught them bicycle safety. In conjunction with the Moline Kiwanis Clubs, patrolman Fisher visited all the schools and tested children on their bicycle-riding abilities. For adults who tested the law, Fisher was the stern, fair officer who would try to use reason, but he was not against using force when needed. Unknown to many is Fisher's fondness for heritage. He was president of the Celtic Historical Trail of the Quad Cities, a group that identified important Celtic historical sites in the area. He was the 1995 St. Patrick Society Parade grand marshal. For years, Fisher tended the rolle bolle courts for the Center for Belgian Culture and was even bestowed honorary knighthood by the Belgian government for his promotion of Belgian culture. He retired at the rank of captain in 1985 and celebrated his 80th birthday in 2015 at a Belgian social club, serenaded by Celtic bagpipers.

Fisher has probably forgotten many details of his career as a policeman. One he will not forget was the afternoon in March 1967 when he witnessed and filmed an unidentified flying object (UFO). He had just parked his patrol motorcycle near Sacred Heart School, where his son was a student. He looked up and saw a bright, strange, silvery object hovering in the sky. Others saw it, too, including his son, other students, neighbors, and even several nuns. Fisher retrieved a movie camera from his motorcycle and filmed some footage. That sighting and film made him an instant witness in an Air Force investigation of several UFO reports in the region during March. Adding credence to the event, Fisher was not the only law-enforcement witness to area UFO sightings. In separate incidents, deputy sheriffs from nearby counties reported strange objects several days before Fisher's sighting. Taking credible witness statements and Fisher's film with them, the Air Force concluded that there was something up there, despite no positive identification. As far as Fisher and his son were concerned, they saw something bright and shiny in the sky that could not be explained or identified. As Fisher's son was quoted as saying, "What we didn't know was way more than what we do know." (Courtesy of Pamela Fisher.)

Dolores Bultinck
Dolores Bultinck was honorary consul for western Illinois and the State of Iowa from 1973 to 2003. She was the first woman to be named an honorary consul by the government of Belgium. In that position, she promoted Belgian-US relations and was able to assist with some legal and consular issues. Bultinck was also a longtime assistant professor of business and economics at Moline's Black Hawk College. (Courtesy of the Center for Belgian Culture.)

Tanilo Soliz
After 64 years of barbering, Tony Soliz (right) finally hung up his clippers. It was not easy, as many of his customers had been coming to his shop for over 50 years. Well respected within the community, Soliz took charge of the Hero Street Monument project to see it to completion. It honors eight Hispanic boys from the same Silvis, Illinois, street who died during World War II and the Korean War. (Courtesy of MDPC.)

Robert Vogelbaugh

Just before Thanksgiving in 1970, Robert Vogelbaugh, owner of a small neighborhood grocery store, asked several elderly customers about their plans for the holiday. They replied that they had no plans, that it would be just another day alone. Vogelbaugh felt he had to do something, and he invited 10 of his customers who would otherwise be alone to come to his store for Thanksgiving, fellowship, and company. After several years at the store, the dinner was opened up to anyone who might be alone, and it was held at South Park Mall. The annual event is not a charity dinner by any means, but it provides a place for people to be with others on Thanksgiving. Around 3,000 meals are dished up each year by Vogelbaugh and over 400 volunteers. Thousands of smiles have earned Vogelbaugh the title "Mr. Thanksgiving." (Above, courtesy of Illinois Farm Bureau; below, courtesy of MDPC.)

Ann Ritchie

Her first name was Ann, but she did not know what her real last name was. Nor did she know exactly when she was born. She was born into slavery, and slave owners did not necessarily keep records or care about such matters. Ritchie knew that she was born in Georgia and lived there before she and her mother were sold to a farmer in Kentucky. She saw her mother sold off to another man, and Ritchie was sold to Dr. Joel Ousley of Burksville, Kentucky, for $1,500. The payment was made in gold, and she became known throughout Kentucky as the "gold slave." Ousley's daughter Helen was married to James Ritchie, and Ann was given to them. As was the custom with slaves, Ann took the last name of her mistress, thus acquiring the name Ritchie.

Life in Kentucky for Ann Ritchie was difficult. As a slave, she witnessed the beginning and end of the Civil War and encountered the activities of the Ku Klux Klan. She met and married, in her words, "the love of my life, Henry Ritchie." Henry had also been a slave on the James Ritchie farm, hence he shared Ann's last name. Their marriage produced eight children, and they moved to Moline around 1877. Henry died in 1890, and Ann died in 1901. Their tombstone listed only approximations of their ages. Her obituary gave her age as 96. The Moline *Daily Journal* printed a story at the time of her death, trying to establish the actual year. The newspaper discovered that about one year after Dr. Ousley purchased Ritchie, there had been a great meteor shower. Ann was said to have been seven years old at that time. Since that meteor shower took place in 1883, it was the paper's belief that Ritchie was about 76 years old at the time of her death. No matter her age, Ann Ritchie had seen sadness, strife, love, and freedom early in her life, and then acceptance in Moline. This photograph of Ritchie is the only known image of her, copied from a tintype. (Courtesy of Kathleen Seusy.)

Katherine Bodenbender

Born in April 1905 in Marburg, Germany, Katherine Zschocke arrived in Moline in 1930 and married Henry Bodenbender. He worked as a blacksmith in the Deere foundry, and Katherine found work as the cook in the home of the president of Deere. Henry soon joined her as the butler. In 1933, the Bodenbenders purchased a small store on Tenth Street and Fourteenth Avenue. They purchase a small house on the southern edge of Moline five years later and added a store that, today, is Katy's Import Foods (below). The store kept hours, but essentially never closed. If someone needed something, the couple would cheerfully provide it. Henry Bodenbender passed away in 1977, but Katy continued to run the store until retiring in 1985. In 2015, this gracious lady celebrated her 110th birthday, making her Moline's oldest living resident. (Left, courtesy of Arthur Bodenbender; below, courtesy of the author.)

Moline Second Alarmers

Local firehouses have long been a gathering place for gossip, card playing, and socializing. A group of local businessmen led by Dwain Christofferson, William Seesland, and William Glendon thought they might put their time to better use by helping the firemen. Their idea was not to fight fires, but to help by rolling and washing hoses after a fire. The idea won the fire chief's blessing, and, in 1952, the Moline Second Alarmers Association was formed. Members assisted at second-alarm fire scenes if extra help was needed. Since 1984, volunteer members respond to any working general alarm fire and provide breathing-air refills (below), cold- and warm-weather rehabilitation services, and fire-scene lighting. The group also responds to neighboring cities and helps rural departments when requested. (Both, courtesy of John Lartz.)

CHAPTER TWO: COMMUNITY LEADERS, INTERESTING DEEDS

Annie Flowerree Velie
Annie Flowerree was the sister of Willard Velie Sr.'s college roommate, where Velie met the fun-loving girl on visits to the Flowerrees' Montana ranch. Graduating from Yale, Velie headed to Montana to marry Flowerree. The couple returned to Moline, where Willard worked for Deere & Company and, later, began building the Velie automobile. On a trip to Italy, Annie fell in love with Italian villas. Velie constructed Villa Velie overlooking the Rock River valley. The home (below) contained 46 rooms, with 14 bedrooms, 12 bathrooms, and an indoor pool. It was the perfect party place for the cigar- and wine-loving Annie. Following the death of her husband in 1928 and her son five months later, she broke her leg while vacationing. She became addicted to pain medication and was put under guardianship for the remainder of her life. She died in 1961. (Both, courtesy of RICHS.)

Benedict Zobrist, PhD
Graduating from Moline High School in 1939, Zobrist entered Augustana College, but left to join the Army during World War II. He returned to Augustana following his discharge and earned a degree in history. Continuing with postgraduate work, he earned a PhD with special interest in American diplomatic history. Dr. Zobrist became the first command historian of the Rock Island Arsenal. Asked to teach a night class in Russian, he enjoyed it so much that he returned to Augustana in 1960 as a full-time faculty member. He concluded his college teaching career in 1969 as chairman of the history department and associate dean of the college. He then joined the Truman Presidential Library (below), where he became its director. His interest in Truman's legacy brought considerable material to the library from former members of the Truman administration. (Left, courtesy of Augustana College; below, courtesy of Harry S. Truman Library and Museum.)

CHAPTER THREE

Arts, Culture, and Academics

Moline's cultural background could be traced to 1872, when the Illinois Legislature passed a law allowing cities to levy a library tax. In 1873, the city established its first public library. The library's existence gave rise to literary societies and educational clubs. In 1878, the Wagner Opera House began attracting actors and singers from Chicago. Local residents could also use its stage for readings and recitals, and local churches used it for services and play presentations. Several of the larger local business firms, like Deere & Company and Moline Plow Company, sponsored bands composed of employees. Notes Band, made up primarily of Belgian immigrants, was another popular entertainment source.

As technology advanced, movie theaters replaced the opera house. By the early 1950s, the city had seven movie houses. Some, like the LeClaire and Illini, were grander than others, but all were popular. Until the 1990s when the Mark Civic Center opened, the closest thing to a civic center was the Wharton Field House. Dean Martin and Jerry Lewis, Jack Benny, Victor Borge, Johnny Cash, and the Tri-City Symphony played that venue, which also hosted sports shows, rock bands, and the annual Easter sunrise service.

Moline has its share of locally and nationally known actors, singers, and musicians. The Music Guild highlights local actors in musical drama and stage plays at its auditorium in Prospect Park. Actor Ken Berry and actress Bonnie Bartlett have been part of national stage and television programming for years. The Moline Boys Choir sang in concerts across America, in Europe, and in Australia, and opera singer Stephanie Sundine has performed around the world. Famed drummer and composer Louis Bellson received musical training at his father's downtown music store.

Moline's gift to art and academia are represented by Richard "Dick" Sargent for his magazine covers, Paul Norton's watercolors, and Michael Blaser for superb marine artwork. Dr. Ken Collinson, Dr. Fritiof Fryxell, and Dr. Curtis Roseman are highly respected in the fields of geography and geology. Richard Kauzlarich was not only a US ambassador, but is an expert in international affairs.

Louis "Louie" Bellson

When his father took him to a parade, three-year-old Louie Bellson pointed to the drum section and told his father, "That's what I want to play." And so he would. Originally taught by Louis Bellson Sr., owner of a Moline music store, Louie also studied with Roy Knapp, who also taught Gene Krupa, Buddy Rich, and other famous drummers. At 17, Bellson won the Gene Krupa Slingerland Drum Contest, beating out over 40,000 other contestants. In the below photograph, Bellson (right) demonstrates his drumming for Gene Krupa. Following high school, Bellson was hired by the Ted FioRito Orchestra. While playing an engagement in California, he came to the attention of Benny Goodman, who hired him immediately. Shortly after, Bellson joined the Army and spent three years playing in Special Services. After the service, it was back to Goodman, then to Tommy Dorsey's Orchestra. (Both, courtesy of MDPC.)

"World's Greatest Musician"

Over the years, Louie Bellson made over 200 record albums with the likes of Count Basie, the Benny Goodman and Tommy Dorsey orchestras, Louis Armstrong, Ella Fitzgerald, his first wife, Pearl Bailey, and Duke Ellington. It was Ellington who called Bellson "not only the world's greatest drummer, but the world's greatest musician." Bellson pioneered the use of the double bass drum setup, created when he was 15. He has written over 1,000 compositions and arrangements for all genres of music, and has written dozens of books on percussion. He conducted numerous drum clinics, like the one shown below in 1966 at Moline High School. Accolades have been plentiful, including six Emmy nominations, the National Endowment for the Arts' American Jazz Master Award, and four honorary doctorates. The entire Quad Cities, especially Moline, is proud to call Louie Bellson a favorite son. (Both, courtesy of MDPC.)

Bonnie Bartlett

From the high school stage to Broadway, television, and the cinema, Bonnie Bartlett has spent over 60 years as an award-winning actress. Her first major role after college was on the daytime drama *Love of Life*. She is probably best remembered for portraying Helen Edwards on *Little House on the Prairie* and Ellen Craig on *St. Elsewhere*. That show earned her two Emmy awards for best supporting actress. (Courtesy of MDPC.)

Malcolm Bosse

After graduating Moline High School as class valedictorian, Malcolm Bosse spent two years in the Merchant Marine, sailing Asian waters. He later graduated from Yale University and began to write novels. Bosse was experienced in the culture of the Orient, and that culture became part of his stories. His novel *The Warlord* became a best-seller, and critics praised him for the historical information within his stories. Altogether, Bosse authored 22 novels. (Courtesy of MDPC.)

CHAPTER THREE: ARTS, CULTURE, AND ACADEMICS

Kenneth Berry
At the age of 12, Ken Berry decided that he wanted to be a singer and dancer. At 15, he won a talent competition sponsored by the Horace Heidt Band. In the Army, he won another talent contest, which earned him an appearance on a New York television program. His dancing ability led to Broadway stage shows, musical revues, and opening acts. Contacts in those venues eventually led Berry to roles in television programs. One of his best-remembered starring roles was that of Capt. Wilton Parmenter in the Western comedy *F Troop*. He is seen below with costars Forrest Tucker (left) and Melody Patterson. Following the cancellation of *F Troop*, Berry appeared on *The Andy Griffith Show*, which led to a starring role in the spin-off *Mayberry R.F.D.* He later appeared on Carol Burnett's *Mama's Family* and in several Walt Disney feature films. (Left, courtesy of MDPC; below, courtesy of WQAD-TV.)

Moline Boys Choir
A concert for the National Music Educators Conference in 1949 launched the Moline Boys Choir. Under the guidance of Frederick Swanson, the coordinator of Moline Public Schools' vocal music programs, 39 boys made up the base of the first choir. Originally a part of the Moline Public Schools, it eventually became a community enterprise separate from the school system. The choir embraced many boys wanting to join and accepted many invitations to perform. By 1958, there were over 150 choir members. Kermit Wells was hired as assistant director and accompanist to help with rehearsing, arranging, and auditioning new applicants. Television appearances and performance tours of the New York World's Fair, Europe, and the South Pacific have highlighted the choir's activities. The above photograph presents the early 1950s formal choir. Shown below is a 1955 television program rehearsal. (Both, courtesy of Steve Slininger.)

Colleen Wilcox, PhD

Following graduation from Moline High School in 1967, Colleen Wilcox earned a degree in speech and hearing sciences. She joined the Peace Corps and implemented programs in speech pathology and audiology in Guatemala. Earning a master of science degree in speech pathology in 1974, Wilcox oversaw a variety of speech and language programs in Arizona and California. She earned her doctorate of philosophy degree in 1986 and served as superintendent of schools for an Illinois special education district before serving for 14 years as county superintendent of schools for Santa Clara County in San Jose, California. Her office served 36 local school districts with over 300,000 students and a budget of $240 million. She founded Silicon Valley Reads, a community reading program, and Fit for Learning, which serves area schools in combating childhood obesity and poor health. Dr. Wilcox has received numerous honors and is an accomplished author and artist. (Both, courtesy of Dr. Colleen Wilcox.)

James Collinson, PhD
Geology is in the blood of Dr. James Collinson, possibly due to his family's ownership of a quarry. After graduating from Moline High School and Augustana College, he earned a doctorate from Stanford University and taught geology at Ohio State University for 30 years. Upon retirement, he continued as a senior scientist with Ohio State's Byrd Polar Research Center. His research included the study of sedimentary rock, paleontology, and Antarctic geology. In 1970, Collinson discovered the first vertebrate tetrapod skeleton in Antarctica. He was part of an expedition during the previous year that uncovered many bones, but no skeletons. These discoveries provided important evidence for continental drift at a time when the theory of plate tectonics was just starting to be accepted by the scientific community.

Collinson Ridge in Antarctica was named for Dr. Collinson by the Advisory Committee on Antarctic Names to honor his research in the area. In 1972, he was awarded the United States Antarctic Service Medal. Collinson received a Fullbright-Hays Senior Research Award at the University of Tasmania to study Triassic rocks in Tasmania and compare them with similar rocks in Antarctica. Dr. Collinson has been on the board of governors of the American Polar Society since 1997, has served as the society's vice president, and is currently its secretary.

Not one to sit idle, Dr. Collinson provided lectures and discussions on Antarctic cruise ships for 13 years, drawing on his considerable knowledge of the continent. He initiated an after-school science club for low-income students at a Title I school in Fort Collins, Colorado. He has also participated in church-related outreach programs, including missions to the Pine Ridge Indian Reservation and to Kenya to assist homeless families. (Courtesy of Dr. James Collinson.)

Michael Blaser

Artist Michael Blaser has spent his entire life along the Upper Mississippi River. As a child, he sketched boats. As an adult with a natural eye and talent for art, he draws and paints the great riverboats that once plied the Mississippi and Ohio Rivers. Blaser has painted in every major river town, and his specialty is steamboats and Great Lakes vessels. After college, he worked as an illustrator and graphic designer. A former corporate art director, he is now a full-time marine artist. His works hang in private, corporate, and university collections throughout the United States. Blaser was the official artist of Cincinnati's Tallstacks celebration in 2006 and of Louisville's Centennial Festival of Riverboats in 2014. A Marine veteran, Blaser also creates military art and has painted several covers for the Vietnam Veterans of America's *Veteran* magazine. (Both, courtesy of Michael Blaser.)

John Getz
John Getz entered the University of Iowa intending to become a teacher, but a class in Shakespeare and performing in plays encouraged him to act. After graduating, he headed to San Francisco and spent time with the American Conservatory Theater and became one of the founding members of the Napa Valley Theater Company. After moving to New York, Getz was given a role in *Macbeth* at the New York Shakespeare Festival at Lincoln Center. Around the same time, he became a regular on the television series *Another World*. He continued to work on and off Broadway, star in several television series, and play major roles in movies like *The Fly* and *Blood Simple*. More recently, Getz spent many months on Broadway in *M Butterfly*. He continues to play roles in episodic television programs and regional theater productions. (Both, courtesy of MDPC.)

CHAPTER THREE: ARTS, CULTURE, AND ACADEMICS

Stephanie Sundine

After hearing the beautiful voice of her third-grade music teacher, Stephanie Sundine knew she wanted to be a singer. She went on to sing solos in her church choir and throughout high school. She graduated with honors from the University of Illinois and performed as a freelance artist with small opera groups as a lyric mezzo. At an audition for the New York Lyric Opera, she met conductor Victor DeRenzi, who convinced her to become a dramatic soprano. He also convinced her to marry him. The couple is seen in the below photograph. Stephanie made her career in operas by Verdi, Strauss, Wagner, and Beethoven, among others, with companies in America, Canada, Europe, and Australia. When she retired from singing, she began directing many regional productions and at several universities. She maintains an active coaching studio to assist singers with role preparation. (Both, courtesy of Stephanie Sundine.)

LEGENDARY LOCALS

Paul Norton
Graduating from Moline High School in 1927, Paul Norton became the art director at an advertising firm. In 1935, he sold his first commissioned painting. He later became the art director of a Moline printing firm, but is best known for painting over 500 watercolors capturing the Midwestern scenes of riverboats, landmarks, and architecture. The below illustration shows the Chicago, Burlington & Quincy Railroad station in Rock Island. Several of his more famous pieces depict the US Capitol, the White House, and the Lincoln Memorial. His paintings are displayed in various galleries, including the White House and Capitol. Besides his paintings, he designed several award-winning floats for the Tournament of Roses Parade. While working as an art director, he designed the company logos for Pella Windows and Dairy Queen. (Left, courtesy of MDPC; below, courtesy of RICHS.)

CHAPTER THREE: ARTS, CULTURE, AND ACADEMICS

Barbara Garst
A 1918 graduate of Moline High, Barbara Garst returned in 1924 and began a 42-year career there. She headed the speech and drama department for 25 years, establishing a tradition of Shakespearian play performances and the study of the Bard's literature. She was the first debate and forensics coach and directed the annual senior-class productions. Garst became the head of the English department in 1950. A world traveler, her descriptions of places and people made literature come to life for her students, as well as making her one of the most popular teachers. During the school's annual parent visitation night, her classroom resembled a class reunion, filled with former students wanting to show their respect. Following her retirement from Moline High, Garst taught at Black Hawk College for several years, where she endowed scholarships for Moline High School graduates. (Right, courtesy of MDPC; below, courtesy of Moline High School.)

91

Richard Kauzlarich

After graduating from Moline High School in 1962, Richard Kauzlarich earned a bachelor of arts degree from Valparaiso University and master of arts degrees from Indiana University and the University of Michigan. Joining the US State Department, he was the director of its operations center (1983–1984), served as a deputy assistant secretary of state for international organization affairs (1984–1986), and was the deputy director of the State Department's policy planning staff, handling global and international economic issues (1986–1989). He was the deputy assistant secretary of state responsible for relations with the former Soviet Union and economic ties with the European Union from 1991 to 1993. In 1994, he was the US ambassador to Azerbaijan and served there until 1997, when he was appointed ambassador to Bosnia and Herzegovina, a posting he held until 1999. He had also served at US embassies in Ethiopia, Israel, and Togo.

Kauzlarich was director of the Special Initiative on the Muslim World at the United States Institute of Peace. He retired from the foreign service in 2002. From 2003 to 2011, he was the national intelligence officer for Europe on the National Intelligence Council. In that position, he was responsible for the analysis of European energy security, Turkey's role as an energy hub, and energy relations with the Caspian region.

In 2011, Kauzlarich was deputy director of the Terrorism, Transnational Crime and Corruption Center at George Mason University in Washington, DC. He became the director of the Center for Energy Science and Policy at the university's School of Policy, Government, and International Affairs in 2014. He is also an adjunct professor, teaching courses on the geopolitics of energy security and on advanced skills for policy professionals.

Not one to slow down in retirement, Kauzlarich is a senior fellow at the Brookings Institute in the foreign policy program, working with the Center on the US and Europe. He is a visiting fellow at the Joint Forces Staff College of the National Defense University. He holds membership in a number of councils and foundations and was an original inductee into the Moline High School Hall of Honor. Kauzlarich is shown below with his wife, Anne, on a visit to the Moline *Dispatch* newspaper offices. (Courtesy of MDPC.)

CHAPTER THREE: ARTS, CULTURE, AND ACADEMICS

Fritiof Fryxell, PhD
Dr. Fritiof Fryxell graduated from Augustana College in 1922, majoring in biology and English. After earning a master's degree, he returned to Augustana to teach, but switched his focus to science. He earned a doctorate in geology and created the department of geology. It was one of the first small Midwest colleges to have such a department. For many years, he was in charge of the school's geology museum and used specimens from it to enhance his classroom teaching, as seen above (Fryxell is at right). Besides teaching the subject, Dr. Fryxell was interested in geology outside of the classroom. As a graduate student, he made a trip to Wyoming's Teton Range in 1924 and spent the next nine summers researching the range. His work was instrumental in designating Grand Teton as a national park. He was an inspiration to his students, more than 150 of who earned master's degrees in geology. (Both, courtesy of Augustana College Special Collections.)

Gary Brown

Many will remember Gary Brown as a football standout at Moline High School and the University of Illinois, or as a teacher, a school board member, a city councilman, or for his long service as a community volunteer. Most know Brown as "Mr. Arrowhead," for his 34 years of service as superintendent of Arrowhead Ranch, the home for at-risk boys. It was there that he created a campus for learning and self-growth, rather than as a place for detention. He helped troubled teens by having them set goals and take ownership of their actions. He had them interact with the public through volunteering at myriad public events. He instilled responsibility in thousands of teens over the years. Brown was a founder of the Moline Booster Club and a 30-year volunteer with the John Deere Classic golf tournament. (Both, courtesy of Nikki Brown.)

Curtis Roseman, PhD
Moline native Curtis Roseman graduated from Augustana College in Rock Island and received a master of arts degree in geography from Southern Illinois University and a doctorate of philosophy in geography from the University of Iowa. Dr. Roseman has held professorships in the geography departments at the University of Illinois and the University of Southern California (USC), where he was also department chair. In 1984, he was a visiting professor at the University of Auckland, New Zealand, and in 1989, a visiting scholar at the University of Canterbury, New Zealand. He retired as professor emeritus of geography at USC.

Dr. Roseman's professional honors and major service awards are many, including the following: president of the Population Specialty Group, Association of American Geographers, 1987; a Fulbright Fellowship for research in New Zealand, 1989; member, International Geographical Union, Population Geography Commission (North American Member), 1988–1992; directed the establishment of the PhD program at USC in 1991 and supervised 15 PhD students; member of the National Science Foundation Geography and Regional Science Review Panel, 1992–1994; National Councilor, Association of American Geographers, 1998–2001; and the 2005 Distinguished Scholar, Ethnic Geography Specialty Group, Association of American Geographers. He has published dozens of journal articles on human migration and ethnic populations and coauthored four books on historic Los Angeles.

Since returning to Moline following his retirement, Dr. Roseman has been extremely active in the local history and geography of Moline and the Upper Mississippi Region. It began with research and a book on the Stewartville area of Moline. He coauthored books on Riverside Cemetery and the history of Wharton Field House and Browning Field. He also heavily researched and authored a book on his Swedish immigrant grandfather, who built many homes in Moline. In 2004, he instigated and chaired at various times the Quad Cities Henry Farnam Committee. Named for the former president of the Rock Island Railroad, the committee organizes an annual dinner and features distinguished speakers on topics that relate to the Upper Mississippi region. Dr. Roseman is a charter member and was first president of Heritage Documentaries, established to write and produce books and video documentaries. He has provided dozens of presentations on a variety of local and regional historical and geographical topics. Dr. Roseman keeps the interest in local and regional history alive in his research, presentations, and publications. (Courtesy of Dr. Curtis Roseman.)

Richard Sargent

Dick Sargent went to work at a local printing plant and took art classes at night following his graduation from Moline High School in 1929. His abilities led him into a career in commercial art for advertising firms and then as a freelance artist and illustrator. He signed on with the *Saturday Evening Post* and painted 47 covers for the magazine. His covers depicted realistic, everyday situations in American life that left the outcome of the scene to the observer's imagination. Sargent's family often served as topics and models for the covers. Below, Sargent displays samples of his covers to businessman William Getz (left) and watercolor artist Paul Norton (center). When photography took the place of magazine-cover illustrations, Sargent turned to fine art painting and moved to Rhonda, Spain. He died there in 1978. (Both, courtesy of MDPC.)

Alice Wheelock

The longest teaching tenure in the Moline school system is held by Alice Wheelock. She might have stayed longer than her 49.5 years if the school board had not revised its rules to require that all teachers retire at 70 years of age. Wheelock began teaching in 1894. By the time she retired in 1943, she had seen many changes within the school system: Kindergarten was initiated in Moline long before other schools adopted the idea; five new elementary schools were built; and a new high school and two new junior high schools were completed. Wheelock was named principal at Garfield School (below) in 1920 and principal at Willard School in 1933. Always firm but fair, she served both schools until she retired in 1943. Wheelock died in 1968 at age 94. (Both, courtesy of RICHS.)

LEGENDARY LOCALS

Benjamin McAdams
As a standout wrestler at Cornell College, Benjamin McAdams was inducted into the National Wrestling Hall of Fame. In the below photograph, McAdams (right) stands with fellow member, amateur champion, and professional star Vern Gagne. For years, McAdams also refereed high school wrestling matches. Sports would not be McAdams's calling; rather, the field of education was his vocation. He was a teacher, principal, and superintendent in several districts before becoming a principal at Moline's Grant Elementary. He spent 15 years as director of special education in the Moline district and, from 1997 to 2001, served as district superintendent. He was later the superintendent at Arrowhead Ranch. An advocate of neighborhood schools, McAdams was elected to the school board in 2013. When the board decided to close two schools and consolidate them into a third amid a huge public outcry, McAdams was the lone dissenting voice against the plan. (Above, courtesy of the author; below, courtesy of Ben McAdams.)

CHAPTER THREE: ARTS, CULTURE, AND ACADEMICS

Adolph Oppenheimer
The physical-training supervisor for Moline schools from 1890 to 1935, Adolf Oppenheimer pioneered organized physical education for schoolchildren and was an early advocate of physical activity for girls. Oppenheimer organized the first of many public displays of physical activities by schoolchildren in 1895. Called Calisthenics Day, the event saw more than 1,000 boys and girls demonstrate running, jumping, dancing, and gymnastics. Later called Field Day, the demonstrations were held into the late 1940s. (Courtesy of RICHS.)

George Senneff
Sterling, Illinois, native George Senneff came to Moline in 1920. He was one of the first high school faculty members assigned coaching duties. And what a coach he was! Senneff coached highly successful football, basketball, track, and swim teams for over 25 years. He later became the school's athletic director. Because he was so well thought of, the swimming pool at the new high school was named for Senneff. (Courtesy of Moline High School.)

Francis Dickens

He was not born here and did not live here, but he is buried here. Francis Dickens, third son of famed English author Charles Dickens, earned renown in the Northwest Canadian Mounted Police, winning medals, promotions, and attending important treaty signings. Upon his retirement in 1886, he was invited to visit and speak in Moline about his danger-filled career as a Mountie. At a dinner prior to the lecture, Dickens was apparently overcome by the heat and died of a heart attack. With no money forwarded from his family, citizens contributed to his burial and headstone. He was buried in a "quiet place" in Riverside Cemetery. In 2002, a group of five Royal Canadian Mounted Police came to Moline and dedicated a new headstone next to the original, weather-beaten marker (below). Bagpipers, buglers, and Dickens Fellowship members from New York dignified the ceremony. (Right, courtesy of MDPC; below, courtesy of RICHS.)

CHAPTER FOUR

Media and Sports

Sports and the media go hand in hand; one provides the action, and the other describes the action. Moline has its share of individuals who have made names for themselves in their respective sports or media professions.

Several of the sports individuals featured here, including Alphonse Anders, Lawrence Eyre, and Gene Shipley, are noted for their amateur abilities and coaching in track, wrestling, and tennis. Baseball is represented by Warren Giles, George Magerkurth, and Dayton Moore with management and officiating. Professional football and basketball provided stellar careers for three Moline High School graduates: Stephen Kuberski, Acie Earl, and Brad Hopkins. Burton Peek, James Jamieson, and Judith Carls represent the world of golf.

Newsmen like Frederick Klann, Jim King, and Thom Cornelis made daily record of the news, sports, and human interest events in our lives. And Keene Crockett and Adam Jones entertained residents on the radio.

These and other individuals made their marks providing entertainment for thousands of local and national audiences with their athletics, writing, broadcasting, and management.

LEGENDARY LOCALS

John Browning
The first attorney in Moline, when it was still a village, was John Browning. He would become Moline's first city attorney, its first president of the library board, and a two-term legislator in the Illinois Assembly. Just prior to his death in 1910, Browning willed some farmland for a public playground and athletic field. This became known as the John T. Browning Memorial Playground and Athletic Field. It is seen in the below photograph, taken in the early 1930s, looking east. The old baseball grandstands can clearly be seen at upper right. The professional baseball team, the Moline Plow Boys, played there from 1915 to the 1940s. The high school baseball team also played there, until the grandstands burned down in 1957. Newly built Wharton Field House is seen at upper left. (Left, courtesy of RICHS; below, courtesy of Moline High School.)

CHAPTER FOUR: MEDIA AND SPORTS

Wharton Field House

Moline High School basketball games had been played in the school's woefully small gymnasium. With basketball growing in popularity, a new facility was needed. A committee determined that the best way to finance an arena was to create a private organization to issue bonds. Thanks to people like T.F. Wharton, Dr. Perry Wessel, C.W. Holmgren, and the bond-buying citizens of Moline, a 5,200-seat field house was dedicated on December 21, 1928. Since that first basketball game, Wharton Field House became the civic center Moline did not have. It was home to Easter sunrise services, boxing and wrestling matches, concerts by famous orchestras and performers, circus and sports shows, and high school graduations. It served as the home floor for two professional basketball teams and hosted political rallies. Below, Richard Nixon speaks inside the field house during his 1968 presidential campaign. (Above, courtesy of RICHS; below, courtesy of MDPC.)

Warren Giles

Warren Giles was asked by Moline community leaders to take charge of the city's ailing baseball team in 1919. He hired Earle Mack, son of famed Connie Mack, as manager. In two years, the team went from worst place to first place. Over the next few years, Giles managed several minor-league teams. In 1936, he was hired as general manager of the Cincinnati Reds. Turning that team around, Giles was named executive of the year by the *Sporting News*. He was named team president in 1947 and became president of the National League in 1951. He oversaw the league's expansion from eight teams to twelve and created divisional baseball. He strengthened the authority of the umpires and won them many benefits. He was considered the best friend umpires ever had. Giles was inducted into the National Baseball Hall of Fame posthumously in 1979. (Left, courtesy of the National Baseball Hall of Fame; below, courtesy of RICHS.)

George Magerkurth

Was he behind the plate or covering third base? The answer will never be known for sure, but Moline's George Magerkurth was umpiring the day Babe Ruth made the famous "called shot" at Wrigley Field. Magerkurth played semiprofessional football and baseball and became an umpire in the minor leagues. In 1928, he was hired to umpire in the National League. During his 19 years in the majors, "Mage" worked four World Series and two All-Star Games. Always considered fair, Magerkurth could still be argumentative with players, managers, and even fans. He ejected manager Leo Durocher seven different times, and he once traded punches with a fan after the fan's team lost a game. Below, Magerkurth (right) is about to eject Boston manager Casey Stengel (left) and catcher Al Lopez for arguing a call too heatedly. (Above, courtesy of the National Baseball Hall of Fame; below, courtesy of Barbara Magerkurth.)

Alphonse Anders

Rated by many as one of the best athletes to come out of Moline High School, 1938 graduate "Flip" Anders was the first in a long family line of athletes. In 1937, Anders won the state championship in the 100-yard dash. He was the state champion in the 200-yard dash in both 1937 and 1938. Records at the high school list Anders as the holder of the current school record for the 200-meter dash, with a time of 21.3 seconds in 1937. After high school, Anders played football at the University of Illinois and Western Illinois University, and he served during World War II. He spent 34 years as supervisor of custodial services at the Quad City International Airport, dealing with everyone from employees to the public. Anders's athletic feats have long added community pride to Moline High School's athletic teams. (Right, courtesy of Moline High School; below, courtesy of Alphonse Anders Jr.)

Howard Shipley
To the many students in Gene Shipley's history classes, he brought that subject to life and gave it meaning. To the hundreds of track and cross-country athletes, he was the highly respected coach who made them strive for their best. His boys' track team won second place at state in 1962, and the cross-country team earned third place in 1988. Perhaps the high point of his 32-year career was leading the Moline Maroons track team to its 1960 state championship, the first downstate team to win that title in 25 years. While there was no ticker-tape parade through downtown, the Moline Rotary did honor the team with a banquet, featuring US Olympian Jesse Owens as speaker. The former Moline Invitational was named for Shipley, and in 2005 the track at Browning Field was named the Gene Shipley Track in his honor. (Above, courtesy of Cindy Meers; below, courtesy of Jerry Wallaert.)

Frederick Klann
After graduating from the University of Michigan, Frederick Klann began working as a cub reporter for the *Detroit News*. Klann was offered a job as a reporter for the Moline *Daily Dispatch* in 1917 and stayed with the paper for the next 50 years. In 1923, he was promoted to city editor. His staff often found him difficult to work for—he despised sloppy writing and reporting—but those same people would say he was the best newsman they had ever met. In 1948, Klann became a featured columnist. His column, "Off the Beaten Path," provided a colorful reminiscence of historical events and personalities that made the news in Moline and the surrounding area. Klann was well-known for his trustworthiness, and interviews for his columns were easily obtained. Some of the best glimpses of Moline's history ended with Fred Klann's death in 1967. (Both, courtesy of RICHS.)

Off the Beaten Path
Peculiar Story-You Learn About Hate - - -
And About an 'Old-Fashioned' Happy World
By FRED KLANN

Jim King (Ketz)

Jim King was hired as sports director at WQAD-TV just before the station went on the air. King is seen at center in the above photograph, flanked by Bob Stuart (left) and Bob Wilford. Within a year, King became the station's news director and primary anchor. For the next 35 years, King was the person most identified with the station. In his role as news director, he made two trips each covering conflicts in the Middle East and Vietnam. In 1970, King was tabbed to produce and host the station's local portion of the Muscular Dystrophy Telethon. For King, it was not just a hosting assignment; he became passionate about the Muscular Dystrophy Association (MDA) and the patients and families it assisted. During his tenure, the local telethon raised nearly $30 million for MDA. King, who died unexpectedly in 1999, mentored many young journalists who moved on to larger broadcast markets. (Both, courtesy of Gloria Ketz.)

Keene Crockett
The golden age of radio saw the rise of Moline's Keene Crockett. After college graduation, he took a job in New York as a page with NBC and discovered the world of sound effects. After serving time as an apprentice, Crockett spent 27 years providing sound effects for such radio shows as *Death Valley Days*, *Superman*, *Inner Sanctum*, and *The Bob Hope Show*. He worked equally well in both comedy and drama. (Courtesy of Keene Crockett.)

Carl Ed
Carl Ed (pronounced "eed") was on the staff of the *Rock Island Argus* from 1913 to 1918. He became a sports cartoonist for a Chicago newspaper in 1918, but created a comic strip aimed at adolescents titled *Harold Teen*. It first appeared in the *New York Daily News* in February 1919. Popular for 40 years, it contained many references to his hometown of Moline. This panel was drawn for the dedication of Wharton Field House. (Courtesy of Moline High School.)

CHAPTER FOUR: MEDIA AND SPORTS

Lawrence Eyre
At age 11, Lawrence Eyre fell in love with tennis. He learned to play at his neighborhood park and became the Quad City singles and doubles champion while in high school. He also qualified twice for the Illinois state tournament. As a freshman at Yale University, he lettered, but chose to pursue singing and was selected for the Whiffenpoofs, Yale's famous a cappella singing group. Eyre has taught tennis to over 15,000 students at camps, schools, and park programs across the country. He was a founding faculty member of Maharishi School at Fairfield, Iowa, and served as its tennis coach. It is the smallest high school in the state, but it has won 17 state championships. In 2009, Eyre was named National High School Coach of the Year by the United States Professional Tennis Association. He is seen below at right with USPTA president Tom Daglis. (Both, courtesy of Lawrence Eyre.)

111

Steven Kuberski

Most everyone at Moline High School knew that Steven Kuberski would go far in basketball. After graduating from Bradley University, where he averaged 23 points per game, he was drafted by the Boston Celtics. He played at Boston for five years before being drafted by New Orleans in the NBA expansion draft. Kuberski was traded to Milwaukee, then Buffalo, both in 1974. In 1975, the Boston Celtics were struggling with inconsistent play. The team again signed Kuberski and won 14 of their next 16 games. The team went on to win its division title and the 1974 NBA championship. The Celtics, with the help of Kuberski, would also be crowned the 1976 champions. Kuberski retired from professional basketball and owns an industrial-supply manufacturing company in the Boston area. (Both, courtesy of NBAE/Getty.)

Acie Earl

Earl, standing six feet, ten inches tall, played varsity basketball at Moline all three years. He helped the team to a 23-4 record in his senior year and was voted First Team All-State by the Associated Press. He played for the University of Iowa and holds the Hawkeyes' career record of 365 blocked shots and is the second-leading scorer in total points (1,779). Additional Hawkeye career records include first in free-throw attempts (725), second in free throws (493), third in field goals (642), fourth in field-goal attempts (1265), and sixth in rebounds (811). He was the 1992 Big Ten Defensive Player of the Year. Earl was a first-round draft pick of the Boston Celtics and later played for Toronto and Milwaukee. He began playing overseas in 1997 and retired in 2004. (Both, courtesy of University of Iowa Athletic Communications.)

Thom Cornelis

It is rare that a broadcaster spends his entire career in his hometown or even in the same broadcast market, but Thom Cornelis did just that for 44 years. He was a basketball and baseball letterman at Alleman High School and a baseball letterman at Western Illinois University. His first job after college was reporting news and sports for Moline's WQAD-TV. As sports director at WQAD, Cornelis (seen above with the *Tonight Show's* Ed McMahon) anchored the station's wrap-up shows for the Quad Cities' annual PGA golf tournament. After 12 years at WQAD, Cornelis moved to Davenport's WOC-TV (now KWQC) to serve as its sports director. Shown below with former Olympian Jim Ryun (left) and Gayle Barron (right), he has anchored that station's coverage of the Bix 7 Road Race for over 30 years. Cornelis was also the first television voice of Iowa Hawkeye basketball. (Above, courtesy of Thom Cornelis; below, courtesy of KWQC.)

Edwin Reimers

Ed Reimers began a long career in broadcasting and commercials at WOC-WHO radio. He was hired one day prior to Ronald Reagan applying for the same announcing position. After serving as a Marine in the Pacific during World War II, Reimers began working in Los Angeles television. His deeply resonant voice brought him announcing work for several Warner Brothers television Westerns and commercials for Skippy peanut butter and Crest toothpaste, among many others. He was also a fill-in announcer for NBC's *The Tonight Show*. Reimers is probably most remembered, however, as the spokesman for Allstate Insurance in television, radio, and print advertising. For 22 years, he reminded everyone that "You're in good hands with Allstate." He would continue to represent Allstate at conventions and award ceremonies, as seen below, until the early 1980s. (Both, courtesy of Kathryn Reimers Manning.)

Adam Jones

Adam Jones, whose real name is Robert Ocepek, spent nearly 12 years in Moline as the host of an overnight radio show called the *All-Night Fist Fight*. Jones had worked at stations in Cleveland, Baltimore, and Louisville before arriving at WQUA in early 1965. His program, consisting of music, conversations with callers, and extremely wry humor, made the show a popular hit with third-shift workers, insomniacs, and students staying up late to work on assignments. Jones did things other announcers would not think of doing, like recording and playing back the 1:00 a.m. hour of his show when clocks were to be turned back at 2:00 a.m. for Daylight Savings Time. Jones left WQUA in 1976, much to the dismay of his listeners. He spent two years in North Carolina and another thirteen in Akron, Ohio, before retiring from the business. (Both, courtesy of Adam Jones.)

CHAPTER FOUR: MEDIA AND SPORTS

Brad Hopkins
Hopkins played both football and basketball at Moline High. On the football team, he played offense and defense, including tight end. As a member of the basketball team, he played forward in the same lineup as Acie Earl. Hopkins was a three-year starter on the University of Illinois football team and earned First Team All-Big Ten and All-American awards. In 1993, he was a first-round draft pick of the NFL's Houston Oilers (later the Tennessee Titans) and became the team's starting left tackle. He earned trips to the 2000 and 2003 Pro Bowl, was named an All Pro in 2000, and played in Super Bowl XXXIV. Hopkins started 188 games and played in 194 games during his 13-year NFL career, all with the same team. (Both, courtesy of Tennessee Titans/DonnJonesPhotography.com)

117

Mathew Lackey

Confident, relentless, and fearless are words that described wrestler Mathew Lackey. Famed University of Illinois coach Mark Johnson stated that Lackey was the best athlete he coached in his 17 years with the school. Lackey began wrestling at age five in a park board program. Good in early programs, in high school, he went undefeated in both his junior and senior seasons. He finished his high school career with a record of 158-13 and was named Illinois high school wrestler of the year. In college, Lackey won the Big Ten title and second place at the NCAA at 165 pounds. He finished with a 38-2 record. His senior year, he won both the Big Ten and NCAA championships at 165 pounds, with a 38-0 record, and was named Big Ten Male Athlete of the Year. (Below, courtesy of Jack Dye; left, courtesy of Matt Lackey.)

CHAPTER FOUR: MEDIA AND SPORTS

James Jamieson
Jim Jamieson began playing golf at age seven. A standout on the Moline High team, he attended Oklahoma State University and earned All-American honors and was a member of Oklahoma's NCAA championship team. Following service in Vietnam, Jamieson turned professional in 1968 and joined the PGA Tour in 1970. He had his best year in 1972, winning the Western Open and finishing eight times in the top 10, including a tie for fifth at the Masters and a tie for second at the PGA Championship. He also played in the 1972 World Cup in Australia. Jamieson's career was cut short by a broken hand in 1977. He became a head club professional at the Greenbrier Hotel in West Virginia, and he has served as a teaching pro at the John Jacobs Golf School. (Both, courtesy of Jack Dye.)

Judith Carls

Carls (above, right) taught physical education and was the first women's golf coach at Moline High. She is pictured with Kathy Whitworth, the winningest golfer on any professional golf tour, with 88 career wins. During Judith's 20 years of coaching, she took her teams to the state tournament 12 times. She also earned Class A status in the LPGA Teaching and Club Professional Division. Upon retirement, Carls moved to California and continued to give golf lessons. Her teaching methods brought her to the attention of Jane Blalock (on the left, below), former multiple winner on the LPGA Tour, who produces golf clinics for women and corporate clients. Carls was hired to organize teachers for these clinics, as well as to teach participants. She was named Golf for Women Top 50 Teacher, an LPGA Top 50 Teacher, and achieved LPGA Master Professional Status. (Both, courtesy of Judith Carls.)

CHAPTER FOUR: MEDIA AND SPORTS

OFFICERS
ROBERT TYRE JONES, JR
PRESIDENT
LEWIS B MAYTAG
VICE PRESIDENT
CLARENCE J. SCHOO
VICE-PRESIDENT
BURTON F PEEK
TREASURER
CHARLES R. YATES
SECRETARY

Augusta NATIONAL GOLF CLUB

AUGUSTA, GEORGIA

EXECUTIVE COMMITTEE
CLIFFORD ROBERTS, CHAIRMAN
FRANK B EDWARDS
ROBERT TYRE JONES, JR
BARRY T LEITHEAD
LEWIS B MAYTAG
BURTON F PEEK
PHILIP D REED

Burton Peek
If the law was Burton Peek's profession, golf was his obsession. A grandnephew of John Deere, Peek worked for several years in the shipping department and as a bookkeeper at Deere & Company. He quit to further his education, graduated from law school, and opened a practice in Moline. He later became treasurer, president, and board chairman of Deere & Company. But just as much can be said about his obsession with golf. Peek was a longtime member of the Augusta National Golf Club (home of the Masters), the club's treasurer, and part of its executive board. He maintained a home at the club and would often play 36 holes in one day. A plaque at the club notes, "Burton F. Peek hit more golf balls at this course than any other amateur in his lifetime." (Both, courtesy of RICHS.)

John Deere Cady
He was the grandson of John Deere and the great-grandson of Linus Yale of Yale Lock Company, but John Cady might best be remembered as a golfer. He was a founder of the Rock Island Arsenal Golf Club and its six-time club champion. He was a member of the silver-medal golf team at the 1904 Summer Olympics and was twice the president of the Western Golf Association. (Courtesy of RICHS.)

Dayton Moore
Following graduation in 1985, Dayton Moore led Moline American Legion Post 246 to a second-place finish in the state Legion baseball tournament. After earning undergraduate and master's degrees, he joined the Atlanta Braves in player development. In 2006, Moore was hired as general manager of the Kansas City Royals. His management led the team to the American League Championship in 2014 after 29 years, and to winning the 2015 World Series. (Courtesy of the Kansas City Royals.)

CHAPTER FOUR: MEDIA AND SPORTS

Porky and Ponce

Growing up, Orville "Porky" Meyers (left) would rather hunt and fish than attend school. But finish he did. Still, his love for the outdoors never left him. He became president of the Moline Conservation Club and began a radio program about hunting and fishing. Meyers met salesman Harry "Ponce" DeLeon during a cocktail party that bored the two men. They realized they both loved the outdoor life, and they teamed up for the radio broadcast, calling it *Along the Outdoor Trails*. By the early 1950s, the radio show led to one of the earliest weekly television programs about the outdoors. Over the next 20 years, the duo recorded their hunting and fishing adventures for the television program and newsletter. Above, Porky mans the microphone, while Ponce, in hat, glasses and tie, looks on during a presentation at one of many sport shows. (Both, courtesy of Judith Carls.)

Vernon Roberts
Roberts was an early barnstormer who became idolized by Charles Lindbergh, who saw Roberts perform aerial maneuvers over Lindbergh's home in Minnesota. Roberts came to Moline in 1927 and became the chief test pilot for Mono Aircraft Company and head of its racing team. He won many national air races during his career. Looking quite dapper in his knickers, he poses below with his Monocoupe racer at the Mono Aircraft hangar in 1928. The radio was a prize he received for winning a regional air race. Not all races awarded cash prizes. The fact that a pilot defeated other pilots flying different makes of aircraft helped establish Roberts and his plane's ability and prominence in the air-racing community. (Both, courtesy of Ken Roberts.)

CHAPTER FOUR: MEDIA AND SPORTS

Mark Civic Center
Since 1928, the largest indoor facility for sports and other events was the Wharton Field House. As time went on, that building became inadequate for larger concerts and for audiences over 5,000 people. Major performers passed the area by, as their shows and all their visual effects were not conducive to the field house. A new civic center was the answer to drawing big-name entertainment. That became a reality in the mid-1980s, when the Illinois Legislature created the Quad City Civic Center Authority. On land along the Mississippi River donated by Deere & Company, the Mark Civic Center (now the iWireless Center) stands. It plays host to concerts, circuses, minor-league ice hockey, rodeos, and collegiate basketball tournaments. Its construction also led to the development of the John Deere Commons, featuring office buildings, a hotel, restaurants, and repurposed historic buildings. (Both, courtesy of the author.)

INDEX

Allen, Clara Belle, 57
Allen, Frank G., 26
Allen, R.A., 57
Allendale, 26
Anders, Alphonse, 106
Atkinson, Charles, 11
Baker, John, 53
Barnard, Herman, 20
Barron, Gayle, 114
Bartel, Robert, 50
Bartlett, Bonnie, 82
Beck, Marshall, 30
Beling, Earl, 49
Beling, Lucille, 49
Bellson, Louis, 80, 81
Bendix, Vincent, 27
Berry, Kenneth, 83
Blalock, Jane, 120
Blaser, Michael, 87
Blaser, Stewart, 52
Blaser, William, 52
Bodenbender, Katherine, 55
Borg, Charles, 30
Bosse, Malcolm, 82
Brown, Gary, 94
Browning, John, 102
Bultinck, Deloris, 72
Butterworth, Katherine, 55
Cady, John Deere, 122
Campbell, Earl, 33
Carls, Judith, 120
Carver, Roy J., 59
Collinson, James, 86
Coopman, William Jr., 66
Cornelis, Thom, 114
Coryn, Edward, 25
Crockett, Keene, 110
Culemans, John, 54
Davies, Ted, 68
Deere, Charles, 16
Deere, John, 12
DeLeon, Harry, 123
DeRenzi, Victor, 89
DeSchepper, Gustaf, 32
Dickens, Francis, 100
Dimock, DeWitt, 14

Dowsett, William, 65
Earl, Acie, 113
Ed, Carl, 110
Eyre, Lawrence, 111
Fahden, Louise, 27
Fisher, William, 71
Flambo, G. LaVerne, 47
Fox, Vincente, 62
Fryxell, Fritiof, 93
Gagne, Vern, 98
Garst, Barbara, 91
Getz, John, 88
Getz, William, 96
Giles, Margaret, 61
Giles, Warren, 104
Gould, John, 13
Harrington, Frederick, 34, 36
Hawk, Leonard, 51
Hinchey, John, 38
Hopkins, Brad, 117
Jamieson, James, 119
Jenny, William LeBaron, 17
Johnson, Kenneth, 68
Jones, Adam, 116
Jones, Eldorado, 31
Kauzlarich, Anne, 92
Kauzlarich, Richard, 92
Keator, Jerman, 15
Ketz, James, 109
King, Jim, 109
Kirk, George, 65
Klann, Frederick, 108
Kohler, Arvid, 68
Kuberski, Steven, 112
Lackey, Matt, 118
Lagomarcino, Beth, 45
Lagomarcino, Lisa, 45
Lagomarcino, Thomas Jr., 45
Lagomarcino, Thomas Sr., 45
Leach, Stanley, 62
Lee, Robert, 56
Lindgren, Chester, 48
Livingston, John, 38
Lopez, Al, 105
Lundahl, Arthur, 35
Lundahl, Frederick, 35

INDEX

Magerkurth, George, 105
Mark Civic Center, 125
McAdams, Benjamin, 98
McAdams, William, 64
McGuire Sisters, 47
McMahon, Ed, 114
Meese, William, 40
Meyer, Robert, 22
Meyers, Orville, 123
Moline Automobile, 37
Moline Boys Choir, 84
Moline Second Alarmers, 76
Montgomery, Alexander, 24
Montgomery, James, 24
Montgomery, Robert, 24
Montgomery, Samuel, 24
Moore, Dayton, 122
Norton, Paul, 90, 96
Noyes, Blanche, 27
Ocepek, Robert, 116
Omlie, Phoebe, 38
Ontiveros, Blenda, 58
Ontiveros, Robert, 58
Oppenheimer, Adolph, 99
Pearson, James, 23
Peek, Burton, 121
Poole, Mattie, 28
Quimby, Roy, 38
Railsback, Thomas, 70
Reimers, Edwin, 115
Ritchie, Ann, 74
Roberts, Vernon, 38, 124
Root, Orlando, 37
Roseman, Curtis, 95
Rosborough, Caldwell, 44
Rosborough, James, 44
Rosborough, Joseph, 44
Rosborough, William, 44
Ryun, Jim, 114
Sandberg, Barbara, 69
Sargent, Richard, 96
Schulzke, William, 43
Seaberg, Severen, 34, 36
Sears, David Benton, 10
Shipley, Howard, 107
Shrader, Richard, 60

Soliz, Tanilo, 72
Stengel, Casey, 105
Stephens, George, 21
Stewart, Jacob, 18
Stewart, Mary, 19
Stewartville, 18, 19, 41, 72
Sundine, Stephanie, 89
Sundquist, Donald, 64
Telleen, John, 59
Thompson, James, 46
Trevor Hardware, 41
Trevor, John, 41
Tunberg, Norma, 48
Tunberg, Robert, 48
Van Dervoort, William, 37
Velie, Annie Flowerree, 77
Velie, Willard Sr., 29
Vogelbaugh, Robert, 73
Wendt III, Earl, 46, 70
Wharton Field House, 103
Wharton, Theodore, 63
Wheelock, Alice, 97
Whitworth, Kathy, 120
Wilcox, Colleen, 85
Wiman, Pattie Southall, 67
Wittick, George Benjamin, 42
Zobrist, Benjamin, 78
Zschocke, Katherine, 75

LEGENDARY LOCALS

AN IMPRINT OF ARCADIA PUBLISHING

Find more books like this at
www.legendarylocals.com

Discover more local and regional history books at
www.arcadiapublishing.com

Consistent with our mission to preserve history on a local level, this book was printed in South Carolina on American-made paper and manufactured entirely in the United States. Products carrying the accredited Forest Stewardship Council (FSC) label are printed on 100 percent FSC-certified paper.

MADE IN THE USA